IMAGES *of America*
PLYMOUTH ROTARY CLUB CHICKEN BARBEQUE

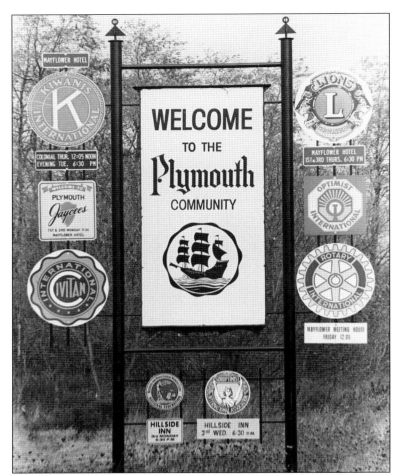

Traditionally, the Rotary Club was a major part of welcoming visitors to Plymouth, Michigan. The year of its founding, 1924, the club contributed to the welcome sign at Plymouth Road and Main Street. In 1963, signs were erected that included meeting dates and times for local service clubs. In 1976, new signs were placed at multiple entryways into Plymouth, including the one pictured here. (Courtesy of the Plymouth Historical Museum.)

ON THE COVER: Event cochair Robert Stremich, wearing the checked safari hat here, reported $10,000 in sales on September 12, 1965, not including ticket presales. The Plymouth Rotary Club's chicken barbeque pit area is always a beehive of activity. The large wheel of the steam engine used for cooking corn is visible on the back cover. While the weather was perfect, the heat from the pits was exhausting. (Courtesy of the Plymouth Historical Museum.)

IMAGES
of America

PLYMOUTH ROTARY CLUB CHICKEN BARBEQUE

Elizabeth Kelley Kerstens and Ellen Elliott

Copyright © 2024 by Elizabeth Kelley Kerstens and Ellen Elliott
ISBN 978-1-4671-6102-2

Published by Arcadia Publishing
Charleston, South Carolina

Printed in the United States of America

Library of Congress Control Number: 2023950816

For all general information, please contact Arcadia Publishing:
Telephone 843-853-2070
Fax 843-853-0044
E-mail sales@arcadiapublishing.com
For customer service and orders:
Toll-Free 1-888-313-2665

Visit us on the Internet at www.arcadiapublishing.com

To the hundreds of Rotarians and volunteers who have toiled through the years to make the chicken barbeque the premier event it is today

Contents

Acknowledgments 6

Introduction 7

1. Serving the Community 9
2. A Rotary Fundraiser with Chicken 19
3. Plymouth Rotary Club's Fall Festival 27
4. A Community Affair 45
5. Bunyea's Steam Engine 57
6. Six Decades of Chicken 61
7. Traditions 103
8. Community Impact 115

About the Friends of the Plymouth Historical Museum 127

Acknowledgments

In 2021, the authors were approached by the Rotary Club of Plymouth to compile and write the club's centennial history. After two years of researching and collecting materials, they began writing and realized that they were going to end up with a boring brick tome. They looked at telling the story a different way and were inspired by the success of the chicken barbeque. That was their angle. Arcadia's Images of America series provided the vehicle for showcasing the far-reaching impact of the event. The year 2023 marked the 66th time that a chicken barbeque was used as a club fundraiser.

The Rotary Club of Plymouth and its members have donated a large volume of documents and photographs to the Plymouth Historical Museum's archives. Within that collection are numerous items compiled by Rotarians Sam Hudson and John Gaffield that allowed the authors to tell the early story of the barbeque. In addition, they are indebted to the following people for supplying photographs: Bill Bresler, Jim Karolyi, Pete Mundt, Paul Sincock, Brenda Turner, and Helen Yancy. They would also like to thank those who have provided valuable information, including Bob Bake, Dan Boyd, Bill Brown, Brandon Bunt, John Buzuvis, Mark Carrigan of Alphagraphics, James Gietzen, Russ Jones, Eric Joy, Penny Joy, Tim Joy, Dale Knab, Chuck Lang, Ron Lowe, Cam Miller, Sandy Mily, Mike Muma, Chris Porman, John Roose, Andy Savage, Ed Schulz, Barry Simescu, Paul Sincock, Jeff Stella, Gary Stolz, Mary Lu Stone, and Doug Willett.

Special thanks to the angels in the archives: Lena Hathaway, Barb Louie, and Pam Yockey.

And they don't want to overlook their ever-patient and supportive family members Joe, Jackson, and Melanie Elliott; Megan Burke; and Marty Kerstens and four-legged friends Coco, Zuzu, and Rosie.

Unless otherwise noted, all images appear courtesy of the Plymouth Historical Museum.

INTRODUCTION

Attorney Paul Harris of Chicago saw a need to create an organization that allowed businessmen of different professions to meet and collaborate. It was 1905. The four original members were Harris, Silvester Schiele, Gustave Loehr, and Hiram Shorey. The name "Rotary" was adopted because the men intended to rotate the meeting locations.

At first, essays on business topics were shared, which later morphed into inviting speakers to the weekly meetings to discuss a wide variety of topics. The idea of community singing was incorporated into the meeting structure. To avoid business rivalries, Rotary established a classification system limiting the number of individuals representing various professions. For example, only one drapery hanger manufacturer was allowed per club. In its first 20 years, what became Rotary International had expanded into 28 countries.

On March 6, 1924, the Rotary Club of Plymouth, Michigan, became Rotary International's club number 1677 with 23 charter members. The charter fee was $100. While club expansion was encouraged, during its first year the charter restricted growth to no more than three new members per month.

From its outset, the club has always focused on community service and better opportunities for citizens of the Plymouth area.

The club held its first meeting at the Penniman-Allen Building; meetings were then held at the Masonic Dining Room on Penniman Avenue, with lunch being served by the ladies of the Order of the Eastern Star. At some point in its first year, the club began meeting at St. Peter's Lutheran Church. Upon completion of the Mayflower Hotel, the Rotary Club held its first meeting in the dining room there on November 11, 1927. Meetings were shifted to the newly refurbished Meeting House, directly across Main Street from the Mayflower Hotel, in January 1967 when it was apparent the club had outgrown space available in the hotel. The club's last meeting there was held on September 23, 1999. The next week, the club began meeting at the Plymouth Community Cultural Center, where it continued to meet as of September 2023.

The Rotary Club's traditions began early. At the January 2, 1925, club meeting, Rotarian Edward Hough presented a Rotary Bell to the club to be used by the president in presiding over meetings. That same bell has been in continuous use at Rotary meetings up to the present day. Guest speakers have been a mainstay at club meetings since the beginning. In 1937, the editor of the club's newsletter, the *Broadcaster*, commented, "How fortunate we are to learn so much from the speakers that come to us each week throughout the year. Information comes to us that would take considerable time to obtain from the reading of books. Such is the atmosphere of Rotary, and we are privileged to belong to an organization where we can come each week and enjoy real fellowship, education, and understanding."

The club's constitution from 1924 made it clear that meeting attendance was important. A member could be terminated for non-attendance if he missed four consecutive meetings unless he made up the meeting at a different Rotary Club and properly notified leadership. Attendance records were

kept and published for many years, and the Rotary district would publish attendance percentages to encourage competition between the clubs. Over time, the strict attendance requirements were relaxed. The club's 2019 bylaws state members were expected to engage with Rotary no less than two times per month, either through meeting attendance or participation in an approved Rotary event, such as the annual golf classic.

The Rotary Club added another major fundraiser in May 1988, when it held its inaugural Plymouth Rotary Golf Classic at Meadowbrook Country Club in Northville, Michigan. That year, money earned supported the Rotary International PolioPlus 2000 Program. In 1990, the golf classic moved to Fox Hills Golf and Banquet Center, where it earned $10,529. In 2023, the event netted approximately $26,000.

Chicken has been a common club tradition throughout the years. It is notable that at the club's charter dinner, fried chicken was served. The first inter-city meeting between the Wayne and Plymouth Rotary Clubs was held at the Plymouth Tourist Camp on July 10, 1925. More than 100 people attended and enjoyed sporting events and a chicken supper. On February 2, 1940, the club held its first "rural urban" meeting at the American Legion Hall in Newburg, Michigan. The Ladies Aid Society of the Newburg Methodist Church provided a chicken dinner.

At the club's 25th anniversary celebration on March 25, 1949, the evening began with a fine chicken dinner followed by an address by the past president of Rotary International Dick Hedke. So it was no surprise when the suggestion was made to hold a chicken barbeque fundraiser in 1956. On September 10, 2023, the Rotary Club completed its 66th chicken barbeque. Through the years, the numbering of the event has been inconsistent because of the two years (1959 and 2020) that the event did not take place.

On the occasion of the club's 75th anniversary, the State of Michigan issued a special tribute, signed by Gov. John Engler:

> Through the insightful leadership of its members, the Plymouth club lists among its many diverse accomplishments its sharing of European relief efforts during the Second World War, funding of student loan and educational programs, donating club proceeds to area hospitals, purchasing hospital equipment, starting the Crippled Children's Home in Inkster, improving parks and recreational areas through beautification programs and construction projects, fostering cooperative community events such as the Plymouth Fall Festival to benefit worthy community projects, supporting cultural programs, and assisting local charitable organizations with fundraising drives. With ceremonies to celebrate its history, the members and officers of the Rotary Club of Plymouth will remember the vision of many people and the hours and years of commitment that have brought the group to this point. Fittingly, as they look to the past, they will also be casting an eye to the future and to the many ways in which the Rotary Club of Plymouth will continue to reach out in our state.

One

SERVING THE COMMUNITY

On December 11, 1923, members of the Wayne (Michigan) Rotary Club held a special meeting to introduce the idea of Rotary to representative men of Plymouth. A survey of the Plymouth area was conducted to determine club sustainability and was quickly approved by Rotary International in early January 1924. William Wood of Plymouth was appointed chairman of the organizing committee. On March 6, 1924, the organizing committee met, along with Rotary District 18's special representative Dr. Edward Lee, from the Wayne club. Wood and 22 other men signed up as the charter members. Plymouth superintendent of schools George Smith was selected as the club's first president.

The Plymouth Rotary Club wasted no time becoming involved within the community. At the end of 1924, the chamber of commerce established a community fund to support needy families of Plymouth. Several members of the Rotary Club were involved in the formation of the fund. To ensure its continued success, a committee was formed of members of the Rotary and the chamber. The first fund drive netted $144; distributions of cash, coal, clothing, fruit, potatoes, toys, and candy were made within the community.

In 1927, charter member Dr. Robert Cooper led the club in conducting a survey of crippled children to identify those in need of assistance, in cooperation with the Wayne County chapter of the Michigan Society for Crippled Children. This survey was done in anticipation of a new state law requiring a census of these children.

Through a collective effort, which included Rotary participation, a summer playground program was organized. School playgrounds were used for this project, and a variety of sporting tournaments, crafts, and musical events were offered during the summer months. The club's interest in the physical health of boys spurred sponsorship of a high school decathlon meet for many years. In addition, the Rotary Club hosted an annual Christmas party for children, which included a special dinner, music, and gifts presented to the guests.

As the club moved forward in time, its members exemplified the true spirit of Rotary and its motto, "Service Above Self."

Officers and Charter Members

President—George A. Smith
Vice Pres.—Edward C. Hough
Secretary—William Wood
Treasurer—Sidney D. Strong
Sargeant-at-Arms—Frank Rambo

Fred D. Schrader	Dr. R. Edward Cooper
Edgar K. Bennett	Roy R. Parrott
Fred A. Dibble	Dr. B. Elon Champe
Charles M. Mather	Lawrence B. Samsen
Otto Beyer	Paul J. Wiedman
Jesse Hake	Harry R. Lush
Carl Shear	John S. Dayton
Harry S. Lee	Harry C. Robinson
Calvin Whipple	Wm. T. Pettingill

District governor Paul King presented the charter to the club at a banquet at Odd Fellows Hall on April 17, 1924. More than 100 Rotarians from neighboring cities, including Detroit, Royal Oak, Birmingham, Dearborn, Wayne, and Ypsilanti, came in support. They enjoyed an elaborate chicken dinner served by members of the Order of the Eastern Star. Attendees were presented favors such as a leather folder designed to hold the Rotary Club membership card. Musical entertainment included

Charter Presentation

Rotary Club of Plymouth

April 17th, 1924

an orchestra interspersed with lively songs by the Rotarians. One of the speakers, Plymouth native Paul Voorhies, expressed his pleasure that a Rotary Club had been organized here and looked forward to the impact it would have on service to the community. The program above was given to all attendees that night.

George Smith moved to Plymouth in 1918 after being hired as the superintendent of schools. Smith was the first president of the Plymouth Chamber of Commerce, was a charter member and first president of the Rotary Club, and was Rotary district governor from 1947 to 1948. His lasting legacy was the George A. Smith Foundation Student Loan Fund, which became the Plymouth Rotary Club Student Loan Fund after Smith died in 1951.

Edward Hough was a native Plymouthite, born here in 1872. He worked at the Plymouth Iron Windmill Company, which became Daisy Manufacturing Company. By 1915, he was vice president of Daisy, and he became its president in 1956. Hough was the second president of the Plymouth Rotary Club and was the chairman of the executive committee that raised funds to build the Mayflower Hotel in 1927. He died in 1959.

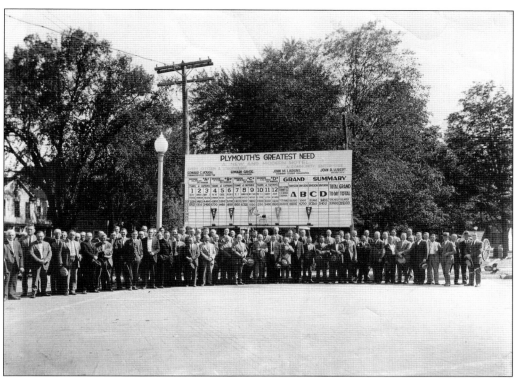

For its first three and a half years, the Rotary Club of Plymouth met in several different locations. It was talk of a regular meeting place that sparked a movement to build a hotel in Plymouth. An organization of 125 businessmen was formed to run the Community Hotel Campaign. Many Rotary Club members served on the committee, including Edward Hough, the chair of the executive committee. At a banquet on September 20, 1926, a total of $175,400 was subscribed; by noon the next day, the final tally of $209,000 was announced. Ground breaking for the hotel began on April 3, 1927; the hotel opened on November 10 that year to great fanfare. The next day, the Rotary Club held the first luncheon in the new hotel, and it continued to meet there for nearly 40 years. The photograph below is the Mayflower Hotel in the 1940s.

In 1930, the Rotary Club met in this elegant room at the Mayflower Hotel. Women were not allowed membership in the club at the time, but 18-year-old Marguerite Wood sits confidently at the table to the right. For many years, singing was an integral part of the Rotary Club meetings, and this young pianist provided musical accompaniment for the renditions of tunes like "Sing a Song to Rotary."

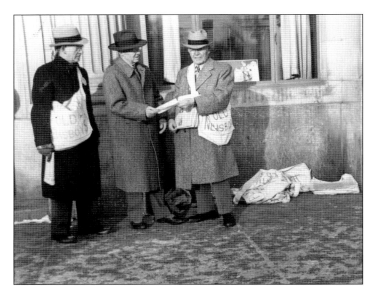

Rotary charter member Harry Robinson was also a founding member of the Plymouth Goodfellows. He is seen here (right) along with James Gallimore and Rotarian Blake Gillies (center)as they get ready for the holiday newspaper fundraiser on December 19, 1942. The Rotary Club contributed more to the campaign that year than any other group with its donation of $150. They helped provide toys, clothing, and food baskets for about 40 local children.

Sidney Strong was a charter member of the Rotary Club. He was also a loyal supporter of the Boy Scout organization. By 1928, the club was sponsoring three Boy Scout troops in Plymouth. The Boys' Work Committee of the Rotary Club was responsible for providing both funding and volunteers to help the troops. Sidney Strong (right) was scoutmaster of Troop 1 and took his role very seriously; his certification card appears below. Strong was recognized in 1939 for 25 years of faithful service to the Boy Scouts. When presented with this award, Rotarian George Smith stated that "no one person in Plymouth has done more to make good citizens of local boys by example and teaching than Sidney Strong." In 1967, he was recognized for 50 years of Boy Scout service. He died two years later at the age of 85.

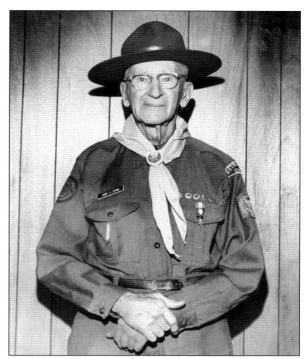

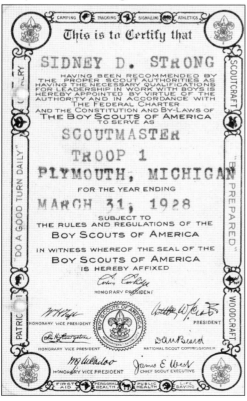

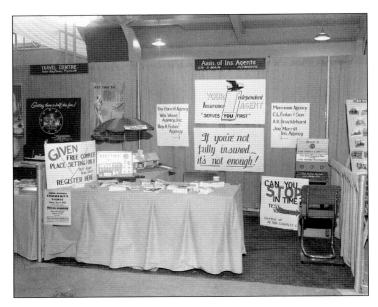

Rotary clubs in southeast Michigan worked hard in 1956 and 1957 to raise funds to build the Western Wayne County Crippled Children's Home in Inkster, Michigan. The Plymouth club joined 10 others selling booths for the Western Wayne Rotary Builders Show in May 1957. Insurance agents from the Plymouth club sponsored the booth shown here and advertised the upcoming chicken BBQ. The club contributed more than $40,000 to this project.

John Blyton announced a new international service project in September 1949. It seemed that neckties were in short supply in Plymouth, England, so a collection was made and the Taylor and Blyton store on Main Street served as a convenient drop-off point. The ties were dry-cleaned by Cliff Tait before they were shipped across the pond. The project proved to be successful with more than 1,100 ties donated.

When Fr. Frank LeFevre was president of the club from 1935 to 1936, he introduced an innovative idea. Each month during the school year, a different high school boy was invited to become a Junior Rotarian. The goal of this program was to encourage a better understanding between the community's youth and local business and professional leaders. It gained widespread attention and was adopted by Rotary clubs throughout the United States.

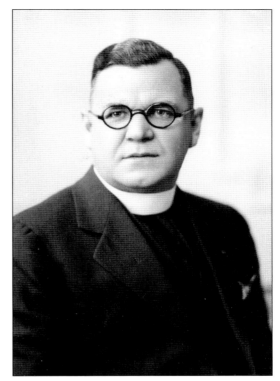

William Wood, a well-respected businessman in the insurance industry, was a charter member of the club and served as the first secretary of the organization from 1924 to 1927 and the fourth president from 1927 to 1928. He was instrumental in preserving Rotary history through his contributions while serving as the writer of the *Broadcaster*, the club's weekly newsletter, which was published beginning in 1925. Wood was the primary writer of the bulletin until 1946.

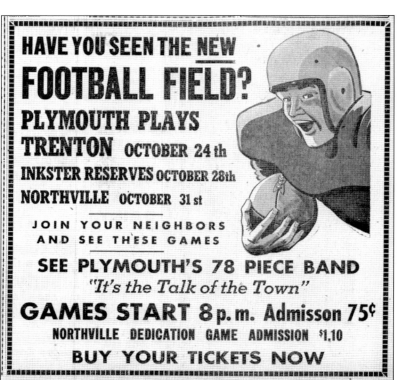

On April 18, 1947, Carl Shear gave a presentation outlining the need for a lighted football field behind the high school. Fundraising began in earnest to raise $25,000. The new space was officially dedicated on October 31, 1947, with Rotary president Paul Wiedman presenting the field to school board president Sterling Eaton. The local team was triumphant when it shut out Northville by a score of 50-0.

Wives of Plymouth Rotarians formed a Rotary Ann club in May 1948. The ladies held their first handicraft sale in December 1949 with profits going back to the handicapped crafters. The club sponsored its first Easter lily sale in 1950, which became an annual event along with the handicraft sale. In this 1965 photograph, Rotary Anns sell handcrafted items in Kellogg Park. The club disbanded in 1989.

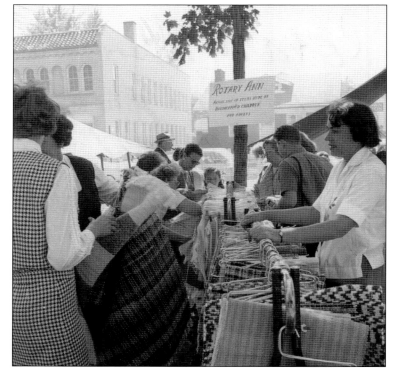

Two

A Rotary Fundraiser with Chicken

In about 1955, the City of Plymouth opened Hamilton Street Playground at Joy, Pine, and Wing Streets. Rotarian Don Lightfoot lived on Joy Street down from the new park and noted the lack of playground equipment. He brought this concern up to his Rotary Youth Activities Committee, which decided on February 2, 1956, to hold a community picnic with a chicken barbeque to fund the purchase of new equipment. On March 5, the city was notified that Rotary wanted to donate money for a specified list of equipment to be bought by the city from the Pioneer Company of Owosso, Michigan. The equipment was received and erected by a city crew before the date of the picnic. The Rotarians hoped to establish a precedent for other service clubs to provide playground equipment for Plymouth's youngsters. On May 22, the city commission passed a resolution thanking the Rotary Club and especially Don Lightfoot as project chairman for this gift to the city.

The next year, the club started planning in May for a second community family picnic, to be held again at the Hamilton Street Playground on June 9, 1957. Because of the success of the first two years, plans for the 1958 event began in August. The Third Annual Plymouth Community Chicken Barbeque was held on Thursday, September 18, at the athletic field of the Plymouth High School. The purpose was to raise money for the Youth Benefit and Community Service fund and to extend a friendly welcome to area neighbors to visit Plymouth. This year, advertising ramped up with the addition of window cards, newspaper ads, flyers, letters to district Rotary clubs, and a telephone canvass. Flyers were distributed door to door and to neighboring Rotary clubs.

The club enthusiastically began preparing for the fourth chicken barbeque in July 1959. Russ Isbister reserved the high school grounds for September 10. A month before the scheduled event, a conflict with the date was realized and it became necessary to cancel. Until 2020, this was the only year the chicken barbeque did not take place.

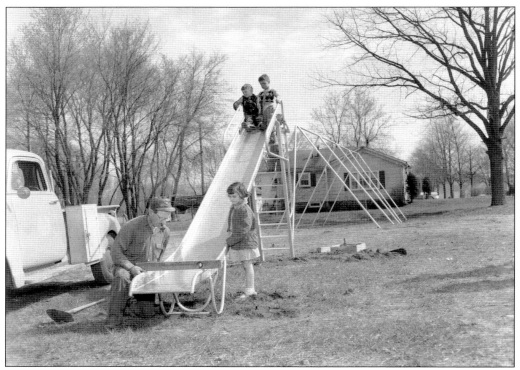

A week before the Community Family Picnic took place in 1956, playground equipment was installed in the space now known as Fairground Park. Under the watchful eye of Glenda Ferguson (right), city workman Ben Zelickman levels the slide. Eagerly waiting at the top of the slide are, from left to right, Russell Maycock, Phillip Denoyer, and Matthew Denoyer. Proceeds from the dinner and a $400 donation from Edward Hough covered the $1,630 project cost.

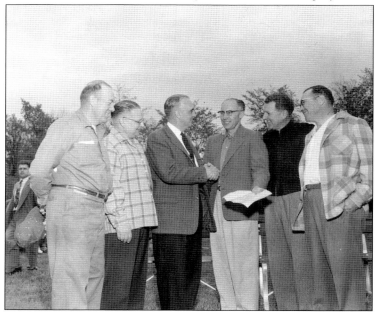

The dedication ceremony for the new community playground was held at the beginning of the picnic on May 20, 1956. From left to right are Rotary Picnic chairman Don Lightfoot, City Manager Albert Glassford, Mayor Russell Daane, Rotary president-elect Donald Sutherland, Rev. Henry Walch, and Walter Beglinger. Walch gave a dedication prayer, and Beglinger furnished some of the labor installing the playground equipment.

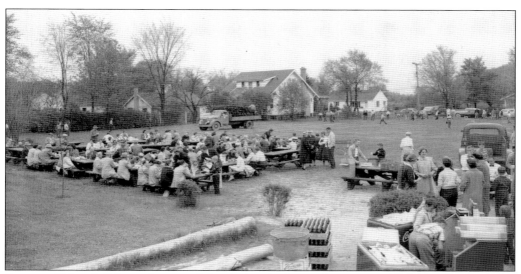

Between 500 and 600 people enjoyed the chicken barbeque dinner served by Rotarians at the site of the new playground at Wing and Pine Streets (now Fairground Park). The menu also included coleslaw, potato chips, coffee, milk or pop, rolls, and ice cream. The afternoon offered entertainment, baseball, and contests. The picnic grossed $955; expenses were $517, so additional fundraising was needed to pay for the playground equipment.

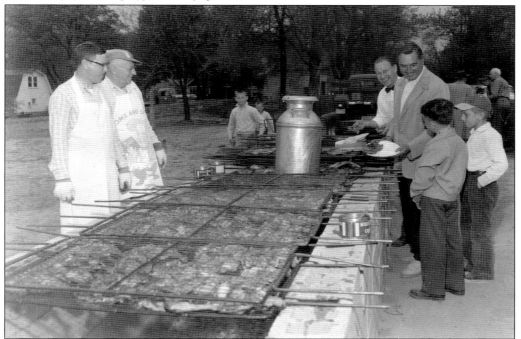

The barbeque pit for roasting the chickens was 40 feet long and was capable of roasting up to 200 chickens at a time. Here, Rotarian Frank Arlen serves plates of chicken to Jeff Lightfoot (left) and Bobby Willis, while fellow Rotarians, from left to right, Harry Draper, Harold Curtis, and Bob Willoughby assist with chicken preparation. Lightfoot was the son of picnic chairman Don Lightfoot.

21

The task of serving 600 meals in the span of four hours was no easy feat and required lengthy preparation. Don Lightfoot (right) was the chairman of the event in 1957 and took his role very seriously. He is seen here examining the poultry offerings with Milt Orr, owner of Bill's Market. The event realized a profit of $505.09.

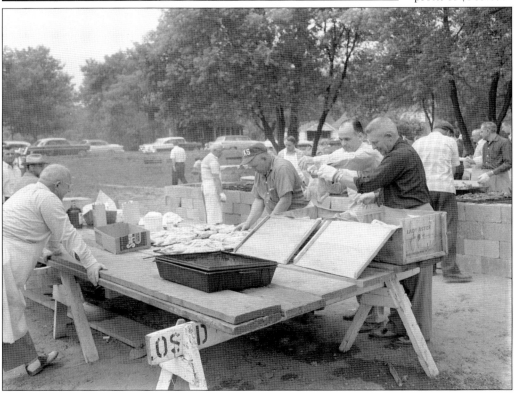

The second annual community picnic was held on June 9, 1957, at the Hamilton Street Playground, where new playground equipment purchased by the Rotary Club was installed in 1956. The chickens purchased through Rotarian Milt Orr came in crates marked Lady Aster brand from the J. Manaster Company of Chicago. Here, committee members add chicken halves to the barbeque racks.

John Salan (left) adds salt to the chicken while Harold Curtis (second from left) puts an additional chicken half on the barbeque rack. Other committee members are unidentified. The Rotary Club began preparing for the second picnic in May, hoping to serve 1,000 people if the weather cooperated. Proceeds were again planned to go toward the purchase of playground equipment.

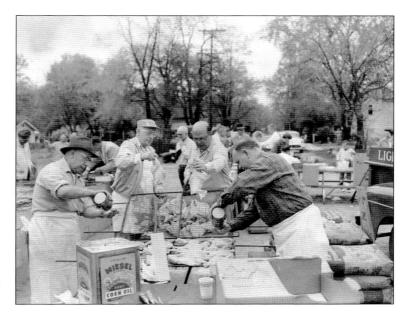

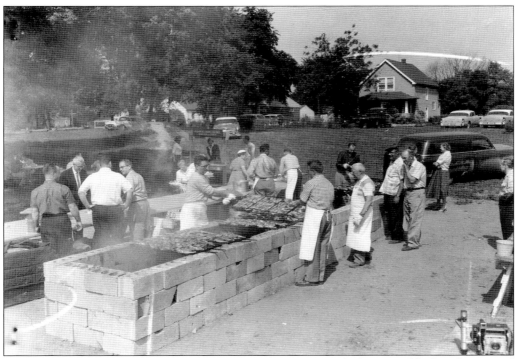

For the community picnic in 1957, a barbeque pit was constructed of concrete block and measured 20 feet in length. The team of cooks was able to grill 100 chickens at a time. The dedicated Rotarians seen here wearing white aprons and skillfully turning the racks are John Gaffield (left) and Charles Finlan. Lending a watchful eye to the right are, from left to right, Dr. Bernice Champe, James Latture, and Don Lightfoot.

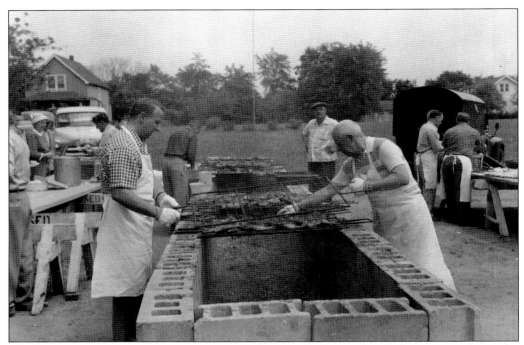

With gloved hands, Dr. Bernice Champe (right) carefully checks the chicken as it cooks on the barbeque pit during the community picnic. He is ably assisted by Charles Finlan. On both sides of the pit, workers can be seen preparing other parts of the meal on makeshift tables constructed of wood planks and road barricades.

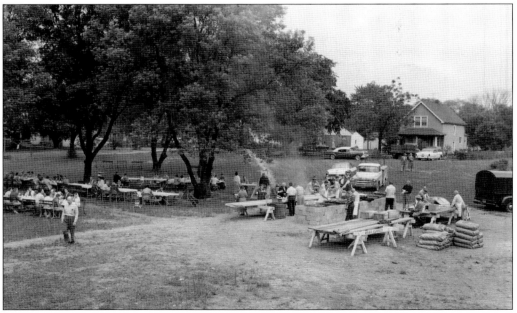

A large number of charcoal bags can be seen on the right as the Rotarians cook the chicken during the 1957 event. The Wayne County Road Commission supplied tables for all of the hungry diners to sit and enjoy their meals under the shade of the trees in the Hamilton Street Playground.

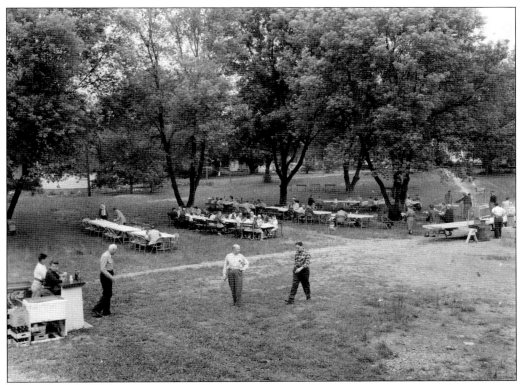

The beverage station (left) for the 1957 picnic was manned by two trusty teenagers. Rotarian Ken Harrison was appointed as the committee head in charge of soft drinks. Diners can be seen in the distance enjoying their meals in the shady park. The Rotary Club requested a donation of $2 for adults and $1.25 for children for each dinner.

The Rotary Club's third community picnic was held on the high school athletic field on September 18, 1958. Expecting a larger crowd, two long barbeque pits were used to roast corn on the cob and 2,000 chickens. The menu also included coleslaw, soft drinks, and ice cream. Tickets were $1.50 for adults and $1 for children under 12. The club's Youth Benefit and Community Service fund profited from the proceeds.

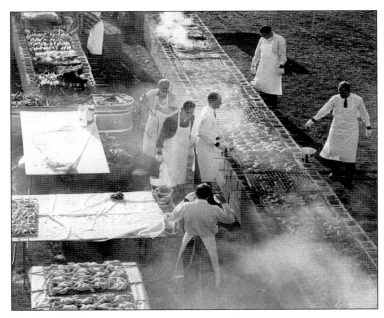

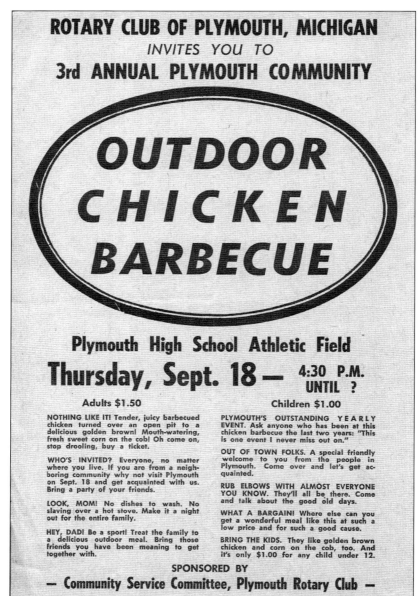

The Rotary Club went all out to advertise its third annual chicken barbeque. Publicity chairman Sam Hudson made sure that flyers were posted everywhere. One week before the event, a comprehensive article was printed in the *Plymouth Mail* that informed the local community about the dinner. Hudson said, "We want to focus attention on Plymouth and encourage folks from outside of the city and other towns to come in and have a marvelous time with us. Anyone who has dined with us the two previous years knows that the dinner is just delicious." The barbeque pits were managed by experienced chefs Don Lightfoot and Dr. Bernice Champe. The ticket chairman, Fred Beitner, oversaw coordinating ticket sales at businesses throughout the downtown area. The committee also announced that local celebrities Soupy Sales and Bud Guest were invited to attend if their schedules allowed. The athletic field was bustling with activity on Thursday, September 18, 1958. This was the last time that the Rotary chicken dinner was held on a day other than Sunday.

Three

Plymouth Rotary Club's Fall Festival

Everything changed when Sam Hudson became president of the Plymouth Rotary Club on June 24, 1960. Within two weeks, the decision was made to broaden the chicken barbeque into a fall festival. Frank Arlen was appointed the general chairman, and each member of the club board of directors assisted as committee chairs. In order to learn more about processes and expansion, several Rotarians made a visit to the Manchester (Michigan) Chicken Broil. That event started in 1954 and was sponsored by the Exchange Club and the Jaycees. Several ideas evolved from this visit that were incorporated into the first Fall Festival, including signage, selling tickets in the park the day prior, high cardboard trash boxes, and radio coverage of the event.

Previously, the barbeque had been held during the week. The 1960 chicken barbeque was held on Sunday, September 11. The change to a weekend date was an effort to allow more Rotarians to work the entire day.

The 1961 barbeque continued the tradition, but this year the sponsor was the Plymouth Rotary Foundation, a nonprofit agency whose funds are used for charitable and civic projects.

The Merchants Division of the Plymouth Chamber of Commerce became involved in 1962, with members Margaret Wilson, James Thornton, and James Houk serving as the Plymouth Fall Festival Committee. Preparations were made for an expanded Fall Festival while Rotary continued planning its chicken barbeque.

Following the 1962 festival, 20 local merchants met at the chamber of commerce to recap the event. The consensus included two specific recommendations: that other organizations in the community plan functions during this week like Rotary's BBQ and that planning for the next year's festival needed to start immediately.

The chamber of commerce created a steering committee that developed recommendations for "continuity of operations and perpetuation of the Plymouth Fall Festival," according to the *Observer of Plymouth* in February 1964. The festival had grown too large for one service organization to sponsor. A plan was put in place to phase out Rotary's exclusive leadership. This provided the framework for the well-oiled machine that is today's Fall Festival Board.

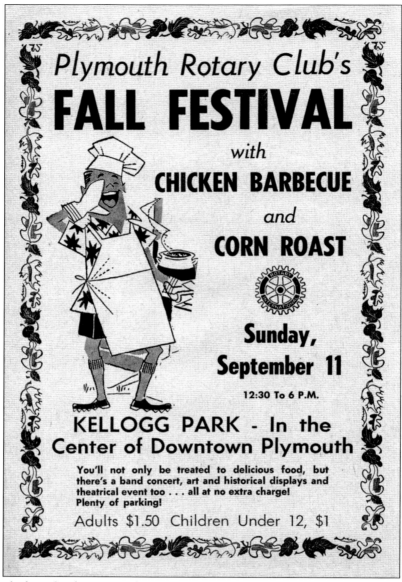

It did not take long for the Rotary chicken barbeque to expand into an event that included more than just a dinner. The high school band provided music, the Three Cities Art Club set up a display, and the Plymouth Theatre Guild provided entertainment for children. The expanded post office was dedicated the same day that the barbeque took place in 1960, and dignitaries from that event were treated to a place of honor at the Rotary chicken dinner. The committee realized success with its method of advertising in 1958, so it continued mailing out flyers, displaying posters around town, and sending press releases to local newspapers and radio stations. At the Rotary meeting a week before the event, Rotarians were reminded in the Rotary *Broadcaster* of September 6, 1960, that "this is our major project of the year, and it is a big job that will require the help of every member of the club." The inaugural Fall Festival, called "the largest effort of its kind ever attempted downtown" by the *Plymouth Mail*, kicked off a tradition that the community would enjoy for generations.

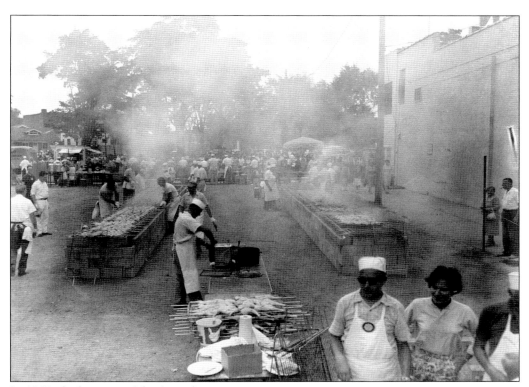

In 1960, the location of the festival was right in the heart of downtown Plymouth with the meal being served in Kellogg Park. The barbeque pits were set up in the empty lot next to the Penn Theatre on Penniman Avenue. The chicken was procured from Weyand Egg and Poultry at a cost of $1,048.78.

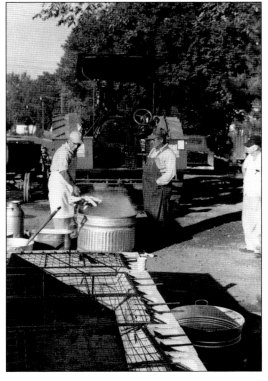

At the first Fall Festival in 1960, Robert Waldecker (left) and Wilford Bunyea boiled corn using Bunyea's 1925 Harrison Jumbo steam engine. The hungry crowds were entertained by the sound of steam blasts from the engine—a sound not heard in the Plymouth area in about a decade, since steam locomotives were replaced by diesel engines. Bunyea had a farm on Powell Road in Plymouth.

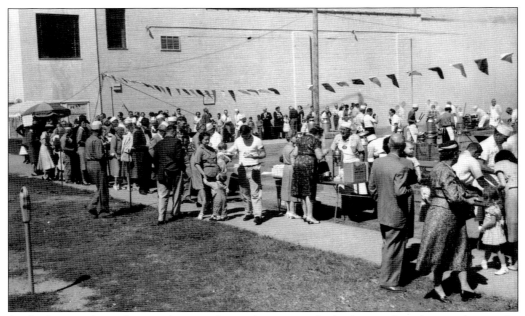

As the hungry diners line up, busy cooks can be seen in the background tending to the pits. In addition to thousands of meals being served, a copious number of beverages were also consumed. Coca-Cola, Squirt, Vernors, and Pepsi-Cola were the top choices of those in attendance. The Rotary Club purchased 20 cases of these thirst-quenchers for $1.25 per case.

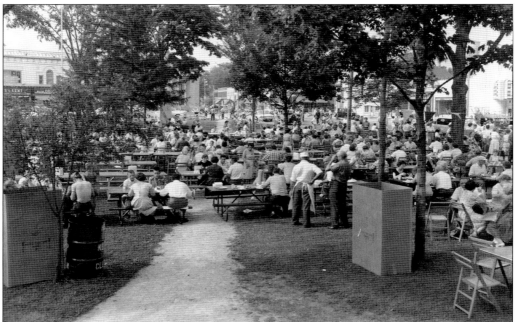

The trees in Kellogg Park provided a perfect shady canopy for diners to sit and enjoy their meals. Tables and chairs were brought in for the day by Dearborn Chair Rental. The Rotarians were proud of their effort in serving 2,750 dinners that year with Frank Arlen leading the charge as chairman of the event.

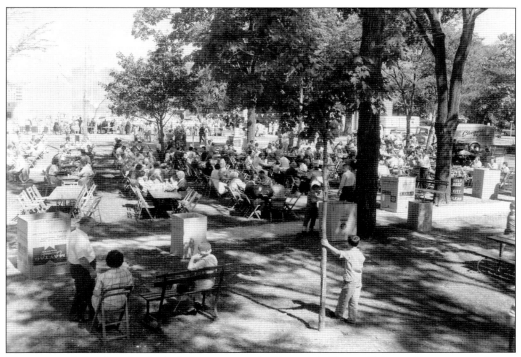

The menu of the day also included ice cream. A Cloverdale Farms Dairy refrigerator truck was parked on Penniman Avenue and can be seen on the far right of this photograph keeping the frozen treats at the perfect temperature. Perry Richwine was the chairman of the committee in charge of these tasty delights and reported that $83.72 was spent on 161 quarts of ice cream.

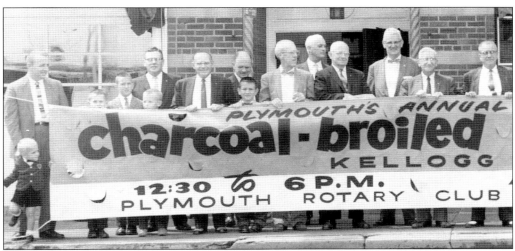

Members of the Rotary Club of Plymouth show off the new banner created for the 1961 Fall Festival and Chicken Dinner. The thirty-by-four-foot advertising tool was made by Distribution Services of Plymouth from the specifications provided by Sam Hudson, the club's past president. The upper portion of the banner had black letters on an orange background; the lower portion had black letters on a white background.

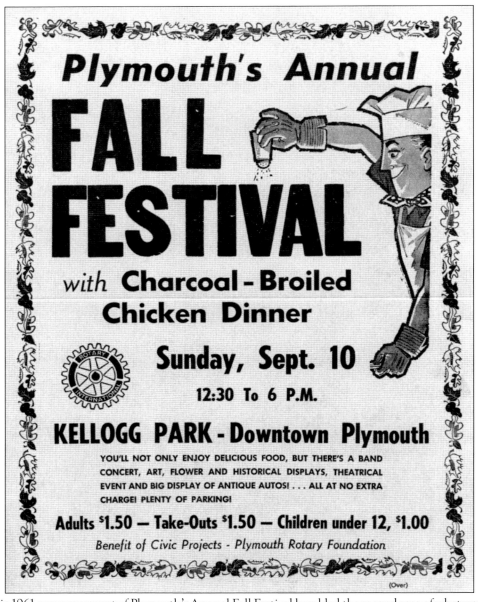

This 1961 announcement of Plymouth's Annual Fall Festival heralded the second year of what would become a long-standing community tradition held in Kellogg Park. For two days before the event, the 84-member Rotary Club sold tickets at the Mayflower Hotel, Food Fair Super Market, Kroger, and the A&P Super Market. The hope of good weather was on the minds of all those involved. Rotary president Earl West confidently told the *Plymouth Mail*, "We've got this well organized, and I understand we have a committee working on the weather." The weather committee must have been on a break at about 2:30 p.m. on that Sunday. As the rain began to fall, announcer Nat Sibbold tried to divert the attention of those present by stating "These trees have a tendency to perspire, it's not raining, it's not raining." A few minutes later the sun returned, and disaster was averted. Event chairman Frank Arlen led the team to produce 2,804 meals for hungry patrons and netted $1,516.47 to support the worthy fundraising efforts of the Rotary Club.

A successful chicken barbeque begins with a properly built pit. This photograph shows two pit rows ready for eager cooks to begin work. Blocks for the pits were supplied by Gould Homes and cost $45.24. The pits were filled with charcoal embers to provide the ideal outdoor cooking setup. Pepper Industries of Birmingham, Michigan, supplied 2,000 pounds of briquets and 175 pounds of charcoal at a cost of $136.40.

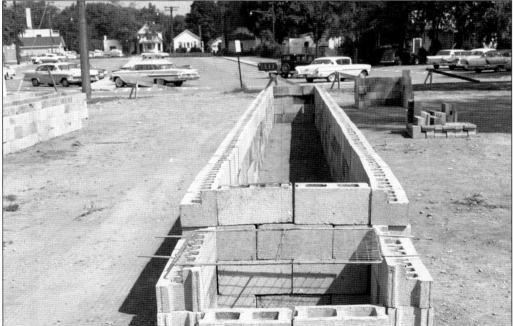

Grids were used to hold multiple pieces of chicken and provided an efficient way to move the chicken down the pit. This photograph shows one empty grid at the front, which was used to ensure the pit was wide enough to accommodate the grids. Sixty grids were rented from Michigan Allied Poultry Industries at a cost of 10¢ each with a cleaning fee of 50¢ per grid.

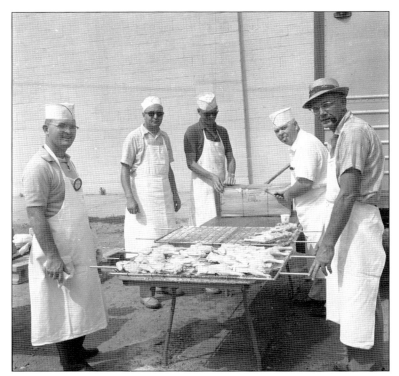

The opening between the Penn Theatre and the Masonic Temple was a beehive of activity. Bill Covington (left) and Elmore Carney (right) laid out the chicken halves on the grids while other Rotarians added secret spices before the grids were put over the charcoal pits. Fifty-six cases of split chicken fryers (twenty-five fryers per case) were purchased from Weyand's in Wayne, Michigan, at a net cost of $1,066.

John Salan, 1961 Rotary corn chef, checks the hose connection from the steam engine to the tub. "We fix a hose very securely from the steam dome to the boiling chamber for the corn," Wilford Bunyea said in an interview in 1984. "We can get a huge chamber of 100 gallons of cold water boiling in about 15 minutes."

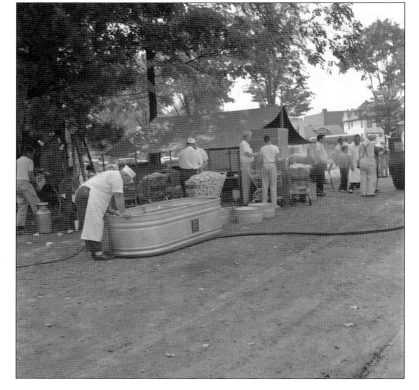

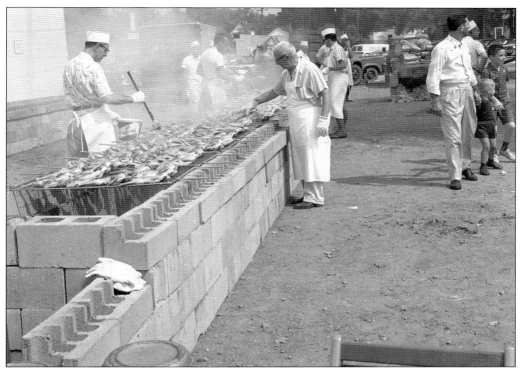

Rotary chefs cooked 2,800 chickens over the course of the Sunday afternoon, dodging raindrops for a short time. The two barbeque pits could handle 600 chicken halves at a time. The chicken ran out about 30 minutes before the festival ended, and 50 ticket holders had to be refunded.

In early August 1961, Sam Hudson, chairman of the Rotary Publicity Committee, sent out a letter to local manufacturers asking them to donate a door prize appropriate for children. Hudson's employer, Evans Products Company of Plymouth, donated the Super 880 Sky Kar pedal car being admired by a hopeful winner. Customers' signed tickets were deposited in a box at the table behind the young boy.

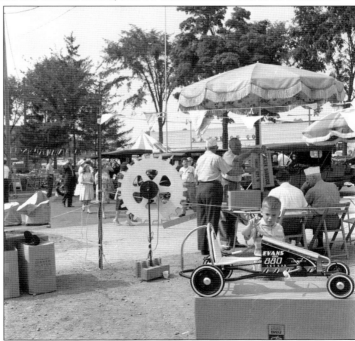

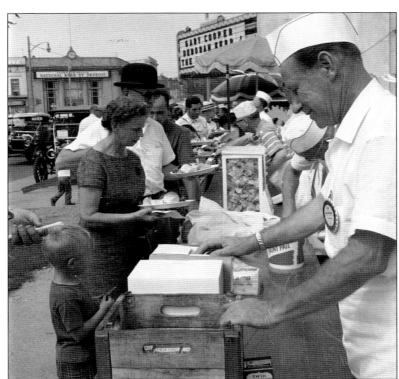

Members of the serving committee ensure ticket holders receive everything on the menu, including drinks. Milk products (in the crate at the bottom of the picture) were purchased from Twin Pines Dairy Products of Plymouth. Chocolate milk was a favorite, as 944 half pints were served alongside 550 half pints of whole milk, at a cost of about 6¢ apiece.

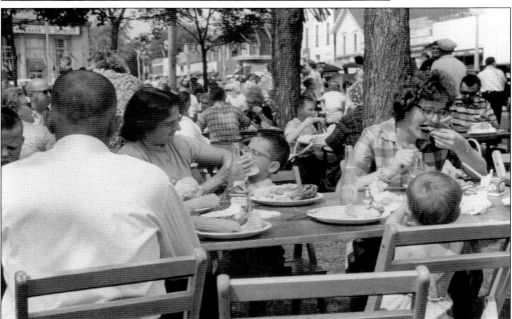

Eating delicious chicken and corn on the cob is a messy endeavor, keeping moms busy wiping little faces. Many families were accommodated in Kellogg Park throughout the Sunday afternoon. The Rotary Club rented 55 long tables and 500 chairs from the Dearborn Chair Rental and Sales Company at a cost of $143.75.

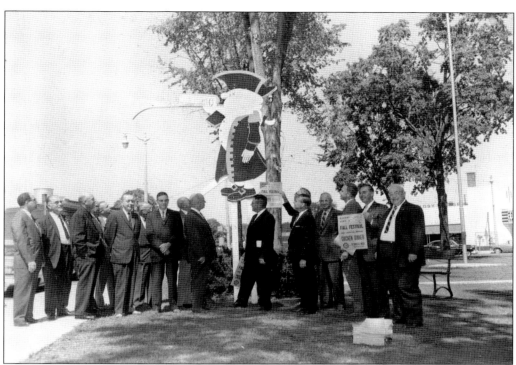

The official mascot of the Plymouth Fall Festival was unveiled in Kellogg Park on Friday, August 17, 1962, by members of the Rotary Club. The *Plymouth Mail* described this new symbol as "the stubby colonial man with the bugle." Sam Hudson purchased the image of a town crier for $2 from Cobb Shinn Company of Indianapolis, Indiana. The iconic figure would later be known as "Johnny."

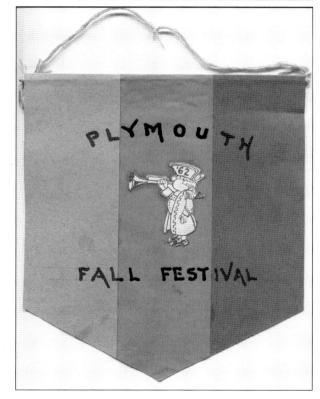

Sam Hudson was cochairman of the Fall Festival Publicity Committee, along with Phil Scott, in 1962. Hudson was the primary driver of incorporating "the little man" into marketing materials. According to Hudson, "Merchants began to use him in their ads and the figure soon became a symbol of the festival."

Dr. Bernice Champe (left) served as the chief chef of pit 1 in 1962. Don Lightfoot was the counterpart chief chef of pit 2. Champe, a local dentist, joined the Rotary Club in 1924 as a charter member and stayed in the club until his death in 1971. Lightfoot was the idea man behind the club's first chicken barbeque in 1956. He joined the club in 1953.

Keeping the coals consistently hot throughout the afternoon was tough work. The club spent $275.15 on supplies for food preparation, including charcoal. Other expenses included $24.80 for aprons and caps, $193.25 for the barbeque racks, $118.80 for rain insurance, and $50 for services provided by Explorer Scout Troop 1533. Net proceeds for September 9, 1962, were $2,463.52.

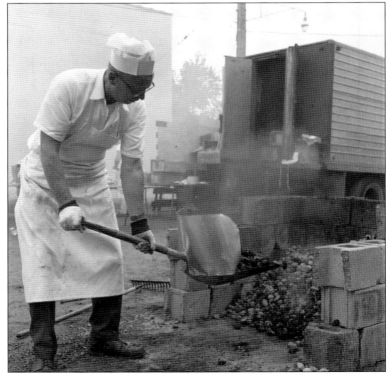

With crowds exceeding expectations, the supply of corn was insufficient to meet the demand. Volunteers ran out to local fields to pick additional ears. This Dodge truck was used to transport the corn to the preparation area, where additional volunteers waited to shuck the freshly picked load to feed the hungry diners. In a newspaper ad, the Rotary Club apologized for the delay in serving while procuring more food.

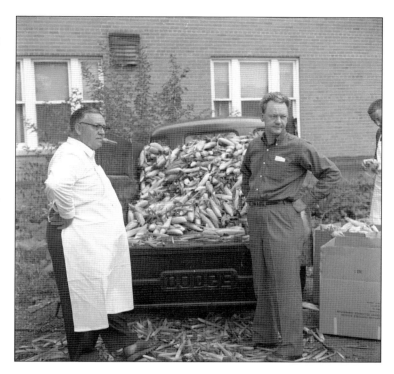

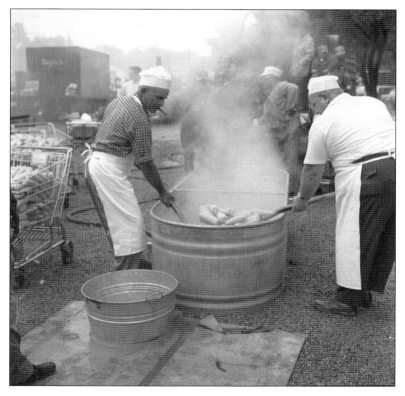

Corn chef John Salan (right) checks the corn being roasted using Wilford Bunyea's Harrison Jumbo steam engine in the background. The engine was originally used by Bunyea for threshing grain. The threshing machine separated the husks and stalks from the seeds. The Rotary Club began using Bunyea's engine in the first Fall Festival in 1960.

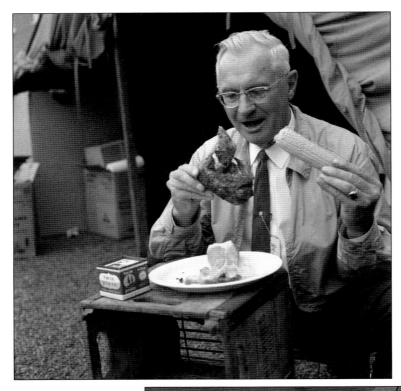

Plymouth Rotary charter member Carl Shear gets ready to enjoy the barbeque feast prepared by his associates. Shear joined Rotary in March 1924 and served as the club's fifth president from 1928 to 1929. Shear owned Plymouth Buick Sales for 33 years and was Plymouth's mayor from 1943 to 1947. He died on June 14, 1974.

From left to right, John Herb, Bob Maurer, and Bob Beyer relax and reflect on a long day of serving the community. Herb was chairman of the 1962 Fall Festival Ticket Committee. Maurer was the Rotary Club's director of community service from 1962 to 1963. Beyer was the club's vice president and director of club service from 1962 to 1963.

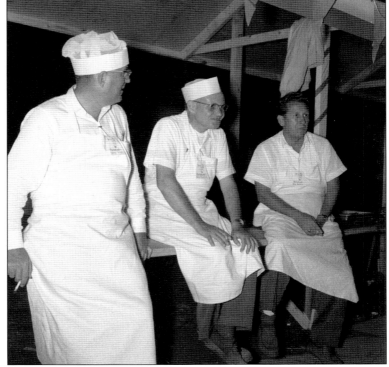

Rotary president Harold Guenther (in a white apron) directs hungry guests to open seats in Kellogg Park. Guenther joined Rotary in July 1952 and served as president from 1962 to 1963. He was a popular mayor of the city of Plymouth from 1957 to 1961. He donated the clock in the median across from Kellogg Park in 1987 in memory of his son Peter. Guenther died on September 8, 1993.

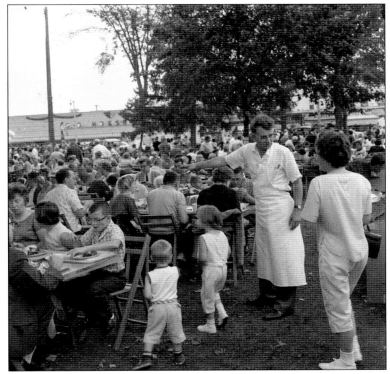

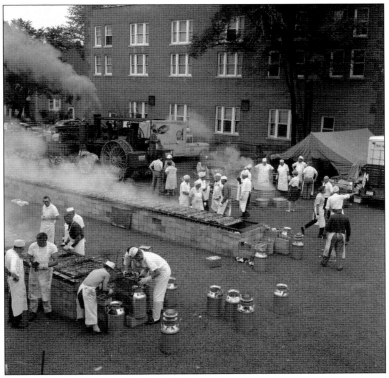

The area next to the Penn Theatre was filled with smoke and steam as the well-orchestrated team worked together preparing meals for the hungry guests. Cooks were busy taking chicken off the grids (left) and loading them into milk cans for quick transport to the serving line. The steam engine was hard at work producing enough energy to cook the corn in the large vat near the supply tent.

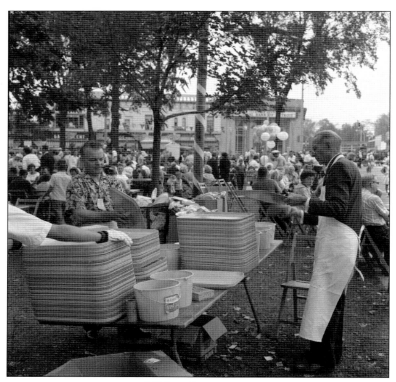

In 1962, meals were served cafeteria style with patrons using paper plates, disposable utensils, and reusable trays to transport their food before finding the perfect spot to sit and eat in Kellogg Park. Rotary volunteers needed to keep up with washing a myriad of trays so that the next round of diners could be served. The cost of serving supplies that year was $291.23.

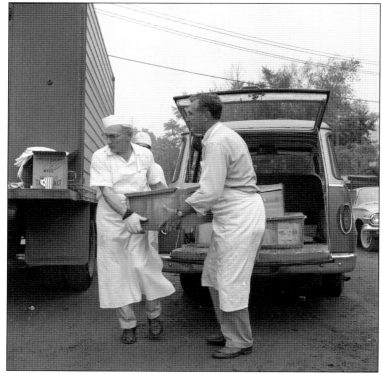

The Rotary Club anticipated serving 4,000 meals in 1962. When crowds exceeded expectations, additional provisions needed to be quickly procured. Mayflower Hotel manager Ralph Lorenz contacted the Kroger warehouse in Livonia; it had a supply of poultry at the ready. Boxes of chicken were expeditiously unloaded from the back of this sturdy vehicle. By the end of the day, a record-breaking 5,270 dinners were served.

The Rotary Chicken Barbeque was truly a community event with local restaurants, like the Hillside Inn, selling tickets and encouraging their patrons to attend. In 1962, the option for take-out orders was offered. Long lines of customers patiently waited while queuing up to enjoy a delicious meal despite the chilly 49-degree temperature and overcast skies. The take-out committee was overseen by chairman Chuck Finlan and cochairman Dave Galin.

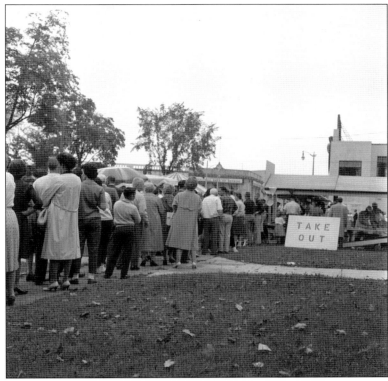

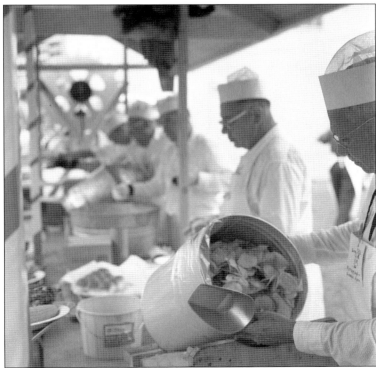

In 1962, dinners were offered at $1.50 for adults and $1 for children. The Rotarians in their spiffy white aprons and chef's hats can be seen serving up tasty chicken and corn on the cob. At the end of the line, a hefty scoop of crunchy potato chips awaited the hungry guests. The serving committee was chaired by Bob Maurer with assistance from cochairmen Wes McAtee, Gerry Pease, and John Zittel.

The Fall Festival quickly grew into an event with broad community participation. In 1962, several local organizations, such as the Plymouth Community Band, Plymouth School of Dance, Three Cities Art Club, Plymouth Garden Club, Plymouth Theatre Guild, and Plymouth Historical Society, provided entertainment, activities, and exhibits for the multiple-day affair. The festival entertainment began on Thursday, September 6, with a performance by a barbershop quartet (above). In addition to concerts and square dancing, there was a pet show that featured about 160 entries, including Dave Martin's "Flying Ant," which took first place in the Most Unusual category. At the 1961 Fall Festival, 30 antique cars owned by members of the Huron Valley Chapter of the Veteran Motor Car Club of America paraded through town. It was so popular that the parade of antique cars returned in 1962 for a Sunday afternoon cruise.

Four

A Community Affair

Prior to 1963, the only food event at the Fall Festival was the Rotary Chicken Barbeque. In late August 1963, Plymouth mayor Richard Wernette issued a proclamation designating September 2 through 8 as Plymouth Community Fall Festival Week. Wernette urged every citizen of the Plymouth community to join in the fun and work to ensure an enjoyable festival.

For years, the Rotary Club set a stellar example of using a food event for fundraising. To that end, in 1963, the Plymouth Junior Chamber of Commerce (Jaycees) and the Kiwanis Club of Plymouth offered meals on Friday and Saturday before Rotary's barbeque on Sunday.

Over the years there were numerous organizations and service clubs that used food to fundraise during the Fall Festival. From popcorn offered in 1962 to myriad food booths in 2023, organizations like the Polish National Alliance Centennial Dancers, the Plymouth Fife and Drum Corps, and the Plymouth Grange have provided tasty treats on each day of the festival. This chapter focuses specifically on scheduled food events during the Fall Festival other than the Rotary Chicken Barbeque.

While photographs were not available for the following groups, they still deserve mention. The Business and Professional Women's Club served a German meal from 1969 to 1975, opening the festival on Thursday nights. The Plymouth Theater Guild dished up a ham dinner from 1982 to 1985. In 1986, the Thursday evening meal was replaced by bingo sponsored by the Business and Professional Women's Club. The Knights of Columbus offered several different meals between 1989 and 1991. The Rotary Club of Plymouth AM served a spaghetti dinner from 2006 to 2019.

These large-scale food events required numerous hours of preparation and volunteer participation for long-term sustainability. For some clubs, the food they offered became too expensive, while others had difficulty maintaining the necessary workforce. By 2021, there were only two food events that survived: the Kiwanis Foundation Pancake Breakfast and the Rotary Club Chicken Barbeque. In 2023, the Rotary Club of Plymouth AM's spaghetti dinner resurfaced, and the Plymouth-Canton Vietnam Veterans of America Chapter 528 introduced a rib dinner.

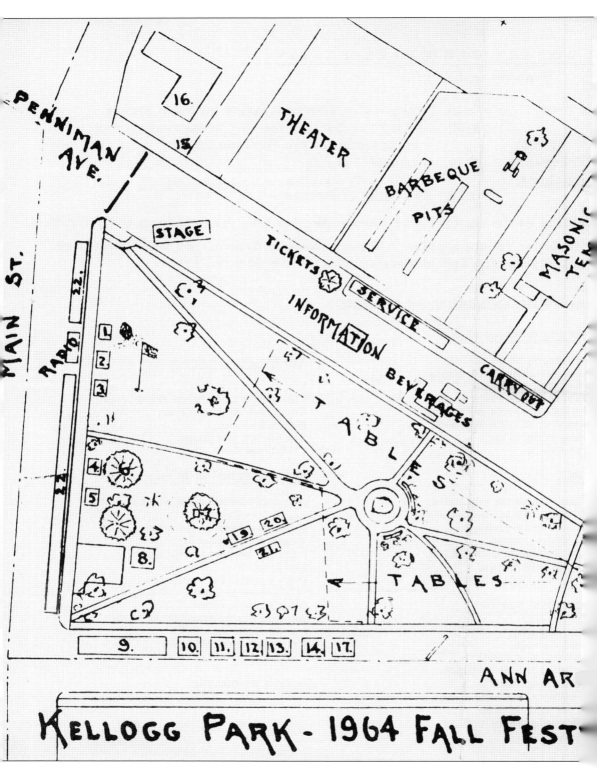

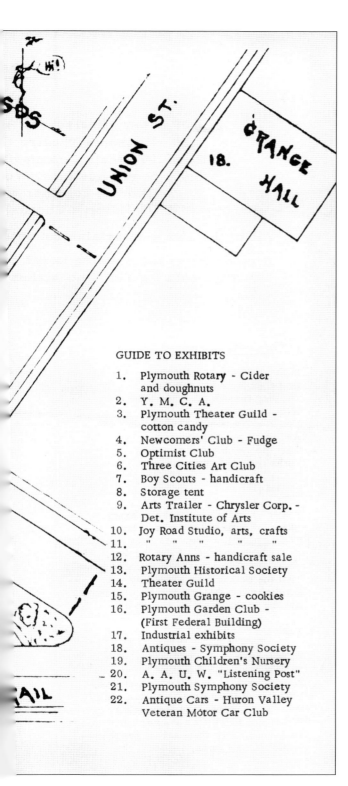

GUIDE TO EXHIBITS

1. Plymouth Rotary - Cider and doughnuts
2. Y. M. C. A.
3. Plymouth Theater Guild - cotton candy
4. Newcomers' Club - Fudge
5. Optimist Club
6. Three Cities Art Club
7. Boy Scouts - handicraft
8. Storage tent
9. Arts Trailer - Chrysler Corp. - Det. Institute of Arts
10. Joy Road Studio, arts, crafts
11. " " " " "
12. Rotary Anns - handicraft sale
13. Plymouth Historical Society
14. Theater Guild
15. Plymouth Grange - cookies
16. Plymouth Garden Club - (First Federal Building)
17. Industrial exhibits
18. Antiques - Symphony Society
19. Plymouth Children's Nursery
20. A. A. U. W. "Listening Post"
21. Plymouth Symphony Society
22. Antique Cars - Huron Valley Veteran Motor Car Club

By 1964, the Fall Festival had expanded to include booths sprinkled around Kellogg Park that sold a variety of food. This bird's-eye view of the layout clearly shows where the Rotary barbeque pits were located between the Penn Theatre and the Masonic Temple. The only streets blocked off were Penniman Avenue and part of Union Street. Food booths included cotton candy sold by the Plymouth Theater Guild, fudge sold by the Newcomer's Club, and cookies sold by the Plymouth Grange. In 1972, Main Street was closed to vehicular traffic from Ann Arbor Trail to Church Street, creating a pedestrian mall. "The new arrangement of having concession booths strung along the curb of Main Street . . . was hailed as one of the most successful experiments ever undertaken by the Festival committee," according to the *Plymouth Mail and Observer* of September 1972.

N⁰ 1684
PLYMOUTH KIWANIS
ANNUAL
ALL DAY FALL PANCAKE FESTIVAL
— *All You Can Eat* —

Saturday, September 9, 1967
7 A.M. TO 7 P.M. PLYMOUTH MASONIC TEMPLE
DONATION $1.00
Let Us Serve You 'n' Serve Plymouth

The Kiwanis Club of Plymouth joined the food parade at the 1963 Fall Festival with its Pancake Festival, which ran all day at the Masonic Temple. Kiwanis had offered an annual spring pancake festival as early as 1955. In 1963, the club held two pancake feasts, in May and September. It continued to be a semi-annual event until the late 1960s, when the club focused its efforts on the Fall Festival.

The Lions Club of Plymouth received its charter on February 5, 1948. Years later, the Fall Festival became an ideal venue for Lions fundraising. In 1963, they sold locally grown melons split in half and filled with Cloverdale ice cream, charging $1.50 per order. In 1969, they began offering a full fish dinner on Friday during the festival; the serving line seen here was also used for the Rotary chicken dinner.

The Kiwanis Club of Colonial Plymouth was chartered in June 1967, becoming the second Kiwanis club in Plymouth. In the 1976 Fall Festival, the new Kiwanis Club took over the Thursday evening meal from the Business and Professional Women's Club. Kiwanians served a spaghetti dinner for $2.50 per ticket. Future Kiwanis International president Gene Overholt (left) and Fr. Ken McKinnon assist with serving the meal.

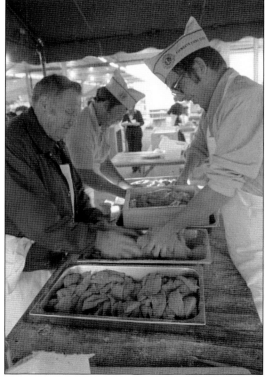

At the Fall Festival in 1977, the community enjoyed the Lions fish fry for just $3, with seniors receiving a $1 discount. Volunteers can be seen here quickly breading the fish before it was transferred to the fryer. The next year, Fred Robinson was the chair of the event, and the process was simplified with pre-breaded ocean perch being used for 3,100 meals that were consumed.

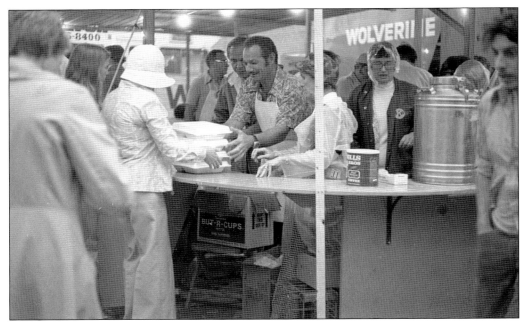

In the second year of the Kiwanis Spaghetti Dinner, the club expected to serve 2,500 meals with spaghetti, roll, salad, butter, beverages, and ice cream. Here, charter member Jim Jabara hands Styrofoam meal containers to ticket holders. Experience taught the club the best way to keep the pasta warm was to precook the spaghetti, blanch it, and then dip it in hot water before pouring the secret recipe sauce on top.

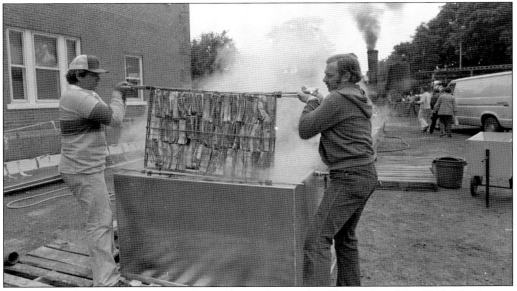

The Junior Chamber of Commerce (Jaycees) was chartered in Plymouth in May 1939. The Jaycees provided leadership training that focused on planning and participating in community service and fundraising events. In 1963, the Jaycees hosted a fish fry at the Fall Festival; two years later, they switched to serving a beef rib dinner. This 1979 photograph shows two hard-working volunteers preparing ribs; note the steam engine in the background.

By 1979, the Kiwanis Club of Plymouth declared that it had reached its peak of production for the annual pancake breakfast, topping out at 2,500 meals. That capacity required advance purchase of 600 pounds of pancake mix and 500 pounds of Bob Evans sausage. Here, Kiwanians Gary Mirto (left) and Marv Terry man the griddles.

The Colonial Kiwanis Club prepared to serve 2,000 meals in 1979, less than the previous year because it eliminated serving at lunch. In 1978, the club purchased a mobile home to use as its kitchen and parked it alongside the Penn Theatre during the festival. Here Kiwanian Greg Ferman happily dishes up spaghetti. (Photograph by Bill Bresler.)

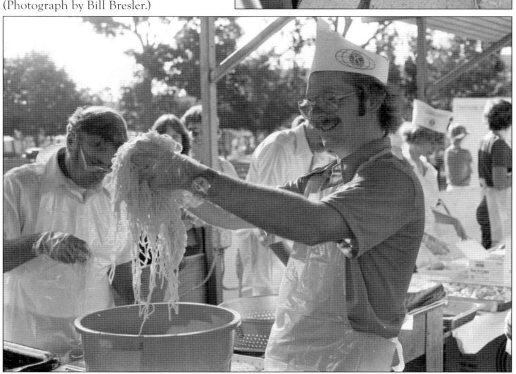

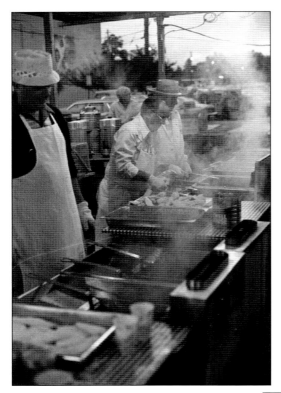

Smoke can be seen rising from the fryers as Lions Club volunteers carefully worked to prepare dinners during the Fall Festival in 1979. Proceeds from previous dinners were used for improvements throughout the community, and new trash receptacles were purchased for the city of Plymouth. The Lions also built two pedestrian bridges in Plymouth Township Park and added picnic tables to enhance the space for visitors.

The Jaycees prepared the beef ribs in the lot next to the Penn Theatre. The pits were shared by the Rotary Club and used on Sunday for the chicken barbeque. In 1980, the rib dinners sold for $4 each. The night before the dinner, about 25 Jaycees met to fill coleslaw cups and shuck 3,600 ears of corn. The group realized a net income of $2,841. (Photograph by Robert Cameron.)

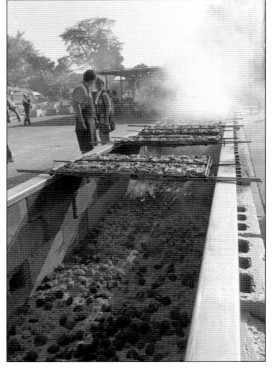

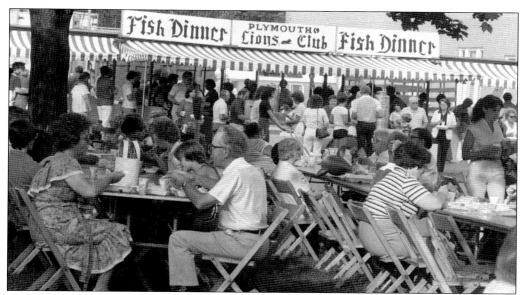

In 1980, approximately 80 people were needed to serve about 3,000 fish dinners during the Fall Festival. The striped awning covering the serving line can be seen in the distance from a vantage point in Kellogg Park. The Lions Club realized a net income of $4,602 that year to support projects related to assisting the blind and improving the lives of people living with physical handicaps. (Photograph by Robert Cameron.)

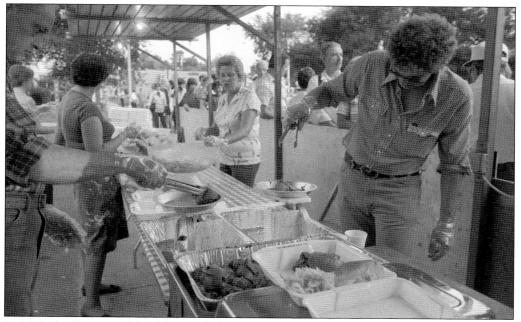

In 1981, the Kiwanis Club of Colonial Plymouth switched course and served a roast beef dinner that included potatoes, salad, roll, ice cream, and a beverage for $4 at the door. Here, Kiwanians measure portions of a third of a pound of beef. Funds raised from dinner sales were earmarked to send two high school students to the state police camp, among other community projects. (Photograph by Robert Cameron.)

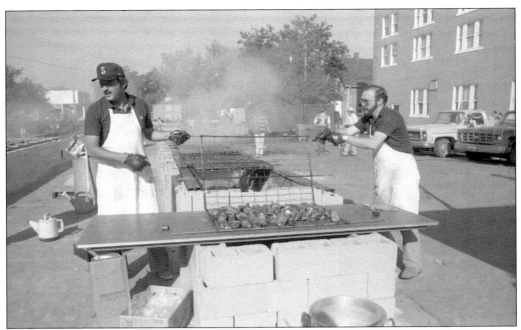

In 1981, the Jaycees were charging $5 for the beef rib dinner, which included a pound of ribs, corn on the cob, coleslaw, and a dinner roll. This photograph shows the end of the cooking line with ribs being unloaded from the grill. The proceeds from the dinner were used to fund a variety of projects benefiting children and senior citizens. (Photograph by Robert Cameron.)

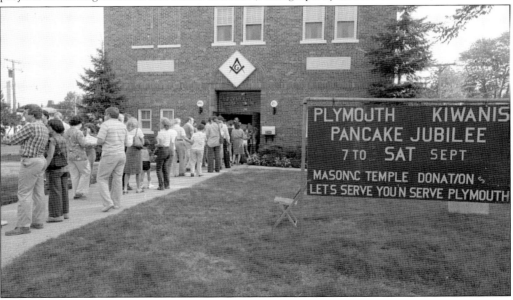

The year 1981 was the last time the Kiwanis Club of Plymouth held its Pancake Jubilee in the Masonic Temple. Lines formed throughout the day to partake in this popular Fall Festival food event. Club organizers ordered about 480 pounds of sausage and 20 cases of pancake mix in preparation. Club president John Egan indicated that the pancake sale was the principal money-making project for the club. (Photograph by Rick Smith.)

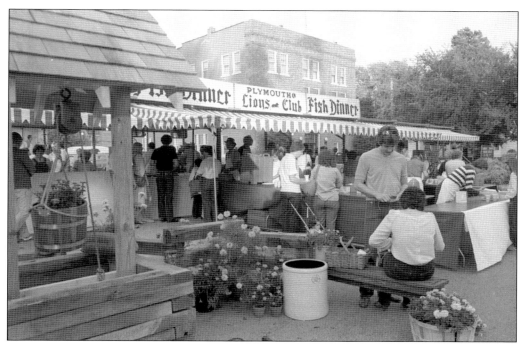

In 1981, the Lions charged $4 for the fish dinner and gave seniors a $1 discount. For the second year in a row, the club won first place in the serving line category of the Marigold Decor contest. They presented an elaborate setting that included a wishing well (left) and an abundance of brightly colored fall plants. The last Lions fish fry took place in 1989. (Photograph by Robert Cameron.)

The Plymouth Gathering on Penniman Avenue was dedicated on May 22, 1983, at the weekly Farmer's Market. It was first used at the 1982 Fall Festival by the Plymouth Theater Guild, which offered a ham and German potato salad meal, replacing the Kiwanis roast beef dinner. Ground was broken at the end of May that year, and construction was completed before the festival. The Gathering was primarily funded by service clubs.

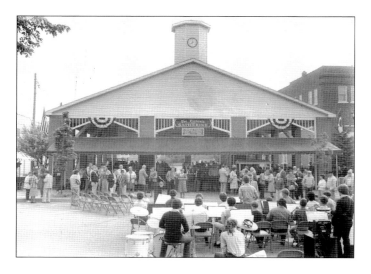

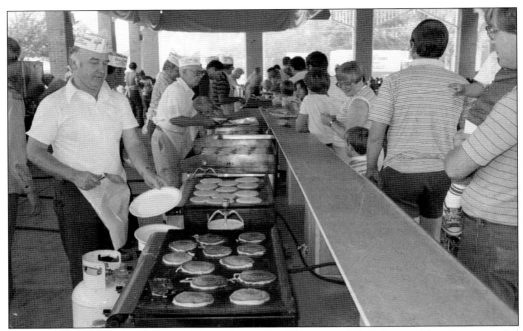

The first year (1982) that the space between the Penn Theatre and the Masonic Temple was roofed to create the Plymouth Gathering was the first year that the Kiwanis Club of Plymouth began preparing and serving its pancake breakfast outside. Kiwanian Terry West (left) grills and serves delicious flapjacks to a waiting crowd. The club served about 1,900 meals with many compliments about being outside. (Photograph by Rick Smith.)

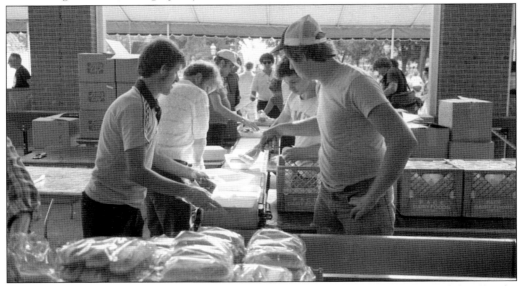

In 1982, the Jaycees had difficulty procuring high-quality beef ribs. Instead, the club offered a sausage meal that cost $3.50 per person and included chips, corn or coleslaw, beverages, and dessert. The conveyor system shown here was used to fill orders for 600–700 meals. In 1984 and 1985, they served a spaghetti dinner, and then they switched to a steak dinner in 1986 and 1987. (Photograph by Rick Smith.)

Five

Bunyea's Steam Engine

Wilford Bunyea was a local Plymouth farmer who owned a Harrison Jumbo steam engine that was a highlight of the Rotary Chicken Barbeque. The 1925 steam engine was in the Bunyea family since 1955, when Wilford's father purchased it. The Harrison Jumbo was made to produce belt horsepower. "This is a steam traction engine as opposed to a locomotive steam engine," according to Guy Bunyea, Wilford's son. "There is a draw bar on this engine to do some plough work, but it wasn't made to pull anything heavy."

The steam engine was used by the Rotary Club from 1960 to 1985. Each year, more than 500 gallons of water was poured through its boiler to produce the steam necessary to cook thousands of ears of corn.

According to Guy,

> There are 56 two-inch steel tubes running through the boiler. Each tube is approximately eight feet long. Water is pumped into the boiler to cover the tubes, while heat is pumped through the tubes themselves. This produces steam in the boiler that moves up to an area known as the steam dome at the top of the boiler. We fix a hose very securely from the steam dome to the boiling chamber for the corn. We can get a huge chamber of 100 gallons of cold water boiling in about 15 minutes.

Guy was attentive to the machine all day to ensure it ran properly. "It's hotter than the devil to work next to that thing all day," he said. In an interview in the *Community Crier* on September 5, 1984, Guy indicated he had been running the engine since he was a kid. He used the machine to help with threshing on his farm. Wilford Bunyea joined the Rotary Club in 1964; Guy joined in 1973.

It is estimated that 842 Harrison Jumbo steam engines were produced between 1898 and 1937. The machine was named after P.T. Barnum's world-famous Jumbo the Elephant.

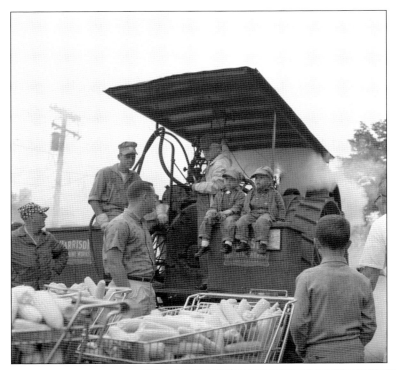

Asay Shear (standing center) operated Wilford Bunyea's Harrison Jumbo steam engine in 1962. Corn was stacked in shopping carts waiting to be steamed. Shear and Bunyea were members of the National Thrashers Association and were neighbors. This heavy machinery needed a skilled operator at the helm. Bunyea trusted Shear, who was a hydraulics instructor at an auto factory.

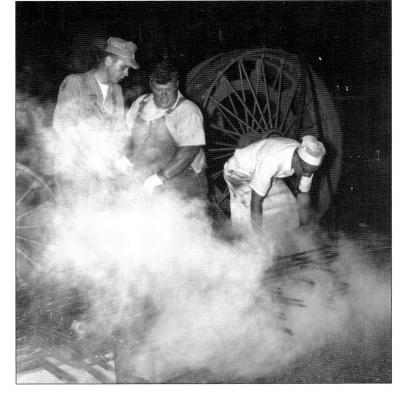

The Plymouth Rotary Club put the steam engine to work cooking and cleaning. Guy Bunyea (center), son of Wilford, helped volunteers steam clean the chicken racks. Part of the cost of renting the racks was cleaning. Using the steam engine helped reduce costs.

For the 1964 barbeque, former Rotarian Robert Sheehan devised an apparatus to steam the corn more efficiently. The new machine, provided at no cost to Rotary, handled 3,000 ears of corn per hour. Sheehan, seen here in a suit and tie, holds a sign with corn chef John Salan acknowledging his company's creation and donation.

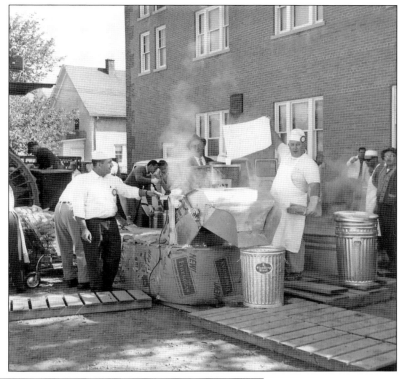

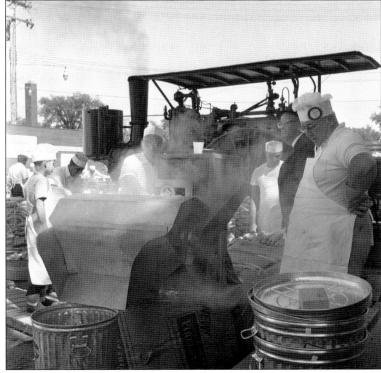

Prior to this invention, steaming the corn was a back-breaking operation. Sheehan's ingenuity allowed for the mechanized process shown here. The corn was loaded onto a conveyor and dropped into an insulated vat. When it was done, a conveyor lifted the corn and dropped it into a clean metal can.

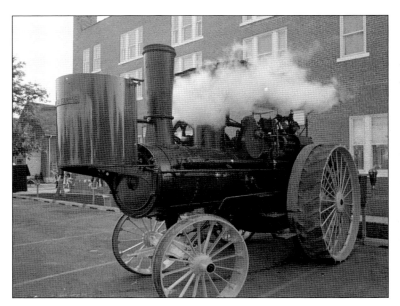

After 26 years of providing steam in food preparation, Bunyea's steam engine made its final appearance in 1985. "The Wayne County Board of Health had some questions about the old steam boiler," said Rotarian Don Skinner. "They were afraid of contamination and asked us to buy a new boiler." Additionally, insurance costs to use the steam engine had risen. (Photograph by Rick Smith.)

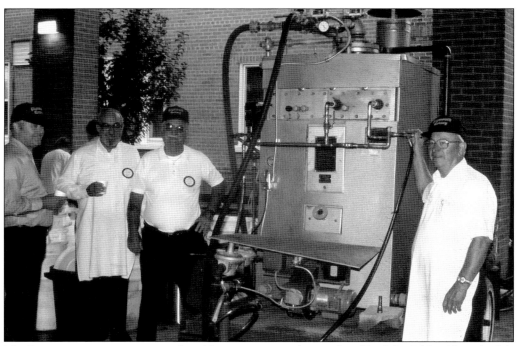

The Bunyea steam engine was replaced by a new system designed and built by Eddie Olson (right). The total cost was $7,931.69 for the entire package. The steam boiler was first used in 1986. Shown here in 1987 are, from left to right, Clifford McClumpha, Coy Tucker, Bill Cripps, and Olson. Cripps donated the steam whistle. This steam boiler has been repaired several times but was still used in 2023.

Six

Six Decades of Chicken

Over the past six decades, the Rotary Club of Plymouth has successfully fed hundreds of thousands of hungry diners at its chicken barbeque. One of the hallmarks of the event is when the steam whistle blows alerting people to significant milestones during the day: when the corn is done being shucked, when the first chicken rack goes on the pit, when the last chicken rack goes on, and when the last rack comes off the pit. Chris Porman, 2023–2024 Plymouth Rotary president, noted that he always looks forward to the final whistle blowing.

The club's membership is made up of a broad spectrum of expertise, which has benefitted innovation throughout the years. Equipment has been developed to improve efficiency and enhance productivity. For instance, the club brings a set of sinks to sanitize the buckets used to transport chicken. Each sanitized bucket holds 50 chicken halves; the buckets have false bottoms engineered to keep the chicken separate from the juices.

One of the biggest changes in production occurred when the Gathering was opened in 1982. This allowed for a covered space for preparation and packaging, and eventually, both pits were moved outside.

The club was able to expand its reach of customers by adding an off-site location for chicken dinner pickup in 1974. The location changed over the years, but the convenience was an added benefit.

From its inception in 1956, the chicken barbeque has traditionally needed volunteer support to fulfill its mission. Hundreds of volunteers representing a variety of groups, from high school teams to area service clubs, are the backbone of the event. According to perennial east pitmaster Cam Miller, "The best part about this entire activity is not the money we raise for the community, it's not that you have 115 leaders of the community that on this day are just grunts, it's the fact that you have 600 volunteers, most experiencing community service for the first time, who come away saying 'that was fun and maybe I like giving back to society.' Hopefully we develop a generation that likes to not just take but give back."

PLYMOUTH FALL FESTIVAL

THURSDAY THRU SUNDAY SEPTEMBER 5 - 6 - 7 - 8

THURSDAY—
Lion's Club "OLD FASHIONED MELON AND ICE CREAM SOCIAL"
KELLOGG PARK — 4:30 P.M. 'TIL 9:00 P.M. — 20¢ to 50¢
BARBER SHOP SINGING — KELLOGG PARK — 7:00 P.M.

FRIDAY—
Jaycee's "OUTDOOR FISH FRY"
KELLOGG PARK — 12:00 P.M. 'TIL 8:00 P.M. — ADULTS $1.50 - CHILDREN $1.00
DETROIT EDISON STEAM CALLIOPE — KELLOGG PARK — 12:00 P.M. 'TIL 9:00 P.M.
OLD TIME GERMAN BAND — KELLOGG PARK — 7:00 P.M.

SATURDAY—
Kiwanis Club "PANCAKE FESTIVAL"
MASONIC TEMPLE — 7:00 A.M. 'TIL 7:00 P.M. — ADULTS $1.00 - CHILDREN 75¢
CHILDREN'S PET SHOW — CENTRAL PARKING LOT — 9:00 A.M.
WASHTA-NONG INTERPRETIVE INDIAN DANCERS—KELLOGG PARK 2:00-4:00 P.M.
GAY NINETIES MUSIC AND SING-A-LONG — KELLOGG PARK — 6:30 P.M.
SQUARE DANCE — CENTRAL PARKING LOT — 9:00 P.M.

SUNDAY—
Rotary Club "CHICKEN BARBEQUE"
KELLOGG PARK — 12:00 P.M. 'TIL 6:00 P.M. — ADULTS $1.50 - CHILDREN $1.00
ENTERTAINMENT ALL DAY LONG

V.F.W. "PAGEANT OF DRUMS"
HIGH SCHOOL ATHLETIC FIELD — 6:00 P.M. — ADULTS $1.00 - CHILDREN 50¢

FRI. - SAT. - SUN.—
"PLYMOUTH ANTIQUE SHOW"
SPONSORED BY PLYMOUTH SYMPHONY — GRANGE HALL & COMMUNITY CENTER BLDG.
12 P.M. 'TIL 10 P.M. - SUNDAY 'TIL 8 P.M. — ADMISSION 50¢ — REFRESHMENTS SERVED

THREE CITIES ART DISPLAYS . . . CARRIAGE RIDES . . . GAILY DECORATED STORES . . . COLORFUL STREET DECORATIONS . . . GAY NINETIES COSTUMES . . . STROLLING ENTERTAINERS . . . REFRESHMENT STANDS
FLOWER CARTS

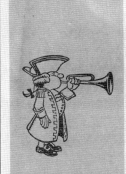

In 1963, the Plymouth Fall Festival became a true community affair. Previously, the only major food event was the Rotary Club's chicken barbeque on Sunday. In addition to non-Rotarians joining the festival committee, the Plymouth Lions Club offered a melon and ice cream social, the Plymouth Jaycees held an outdoor fish fry, and the Kiwanis Club of Plymouth made pancakes all day. The theme for the four-day festival, which drew more than 25,000 attendees, was turn-of-the-century Plymouth. Merchants decorated accordingly, antiques were displayed throughout downtown, and many people dressed in period attire. According to the *Observer of Plymouth*, "Nary a one of the many programs was a financial flop, all finishing in the black." The general chairman of Rotary's BBQ event was Ed Sawusch; his cochairmen were Kal Jabara and Robert Stremich. One of the added features this year was offering special prizes for children with winning chicken dinner tickets.

In 1962, Rotarian Frank Arlen designed steel caps to put on top of the angled concrete blocks over the full length of the barbeque pits. This innovation was projected to cut the work of the pit workers by 50 percent. This picture was taken in 1963 and shows the steel caps being put in place.

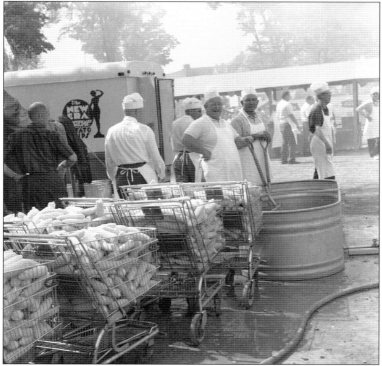

Veteran corn chefs John Salan (center) and Robert Waldecker managed the steam from Bunyea's steam engine and ensured the corn was cooked properly in the large trough. Loading the shopping carts with ears of corn made the task of dumping the corn into boiling water an easier task during the nine hours Rotarians spent cooking.

63

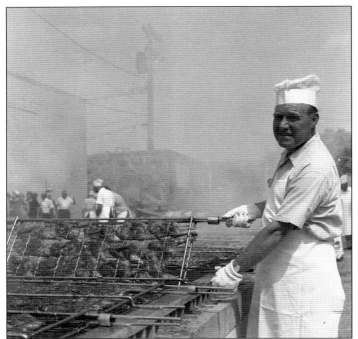

Sam Hudson rotates a chicken rack during the 1963 Fall Festival. Hudson joined Rotary in 1953 and served as the club president from 1960 to 1961. During his presidency, he was instrumental in elevating the chicken barbeque from an afternoon affair to a Fall Festival in Kellogg Park with a band concert, historical displays, and a theatrical event.

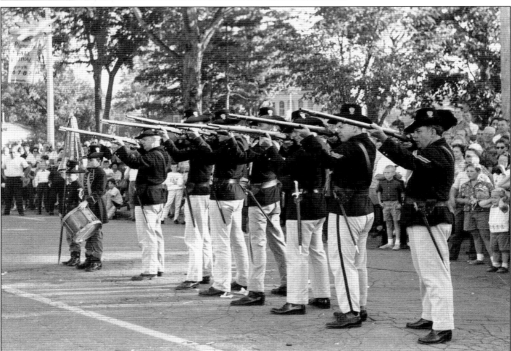

Midway through the Rotary Chicken Barbeque on Sunday, September 8, 1963, reenactors of the re-created C Company, 24th Michigan Infantry Regiment gave a firing demonstration using blank rounds and authentic Civil War muskets. The original company was formed in Kellogg Park in 1862 and became part of the famed Iron Brigade, participating in many battles, including Gettysburg.

In 1964, Rotary's chicken barbeque was held on Sunday, September 13. More than 11,000 dinners were served that day, about 2,000 more than in 1963. Dinners were served on trays to those eating in the park. Carry-out dinners were also available. On the left in this picture is a display of the donated prizes available for children who held the winning chicken dinner tickets. (Photograph by John Gaffield.)

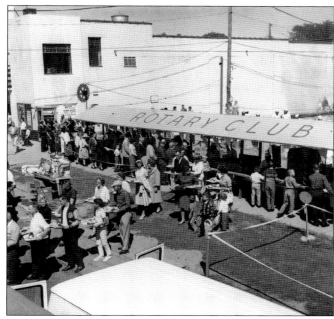

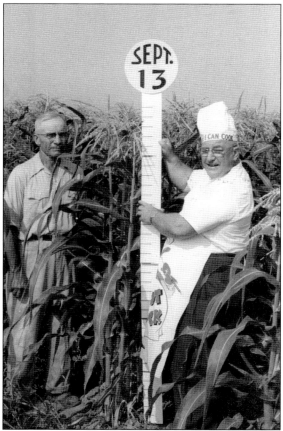

In August 1964, Rotarians Robert Waldecker (left) and John Salan met at Waldecker's farm in Plymouth to measure the growth of corn destined to be used in Rotary's chicken barbeque. Salan and Waldecker were chair and cochair of the corn committee in 1964 and had worked together cooking corn for several years before then. This was Waldecker's final barbeque, however, as he died in October 1964. (Photograph by John Gaffield.)

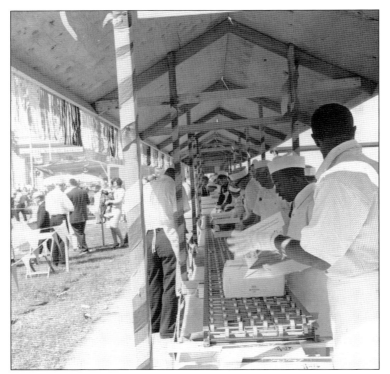

The chairman of the 1965 barbeque was Robert Stremich. One of the innovations added for this year's barbeque was a roller conveyor to assist with delivering meals more efficiently. To put this new system to the test, the meal components were assembled into take-out boxes—another new feature added in 1965.

Charter member John Dayton and his wife, Gertrude, enjoyed the chicken dinner prepared by his fellow Plymouth Rotary members in 1965. Dayton, an attorney, joined Rotary in March 1924. When he died on July 10, 1974, the chapter closed on the club's charter members. Although he had moved to Florida, Dayton attended club meetings during the summer until about 1971.

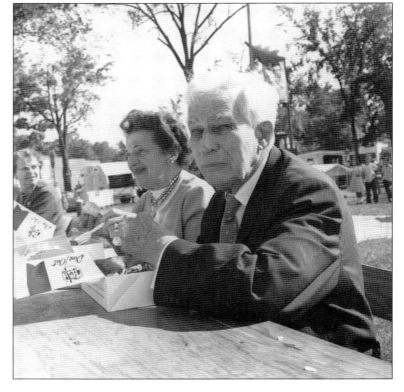

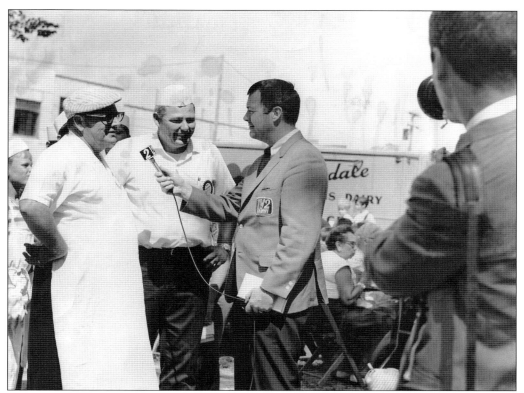

The 1968 Rotary cochairman Robert Sincock (left) and chairman Warren Bradburn were interviewed by WJBK TV-2 news anchor Jac LeGoff during the afternoon of the chicken barbeque. WJBK was the CBS affiliate in Detroit, where LeGoff was an anchor for about two decades. The Rotary Club had a very active publicity committee headed by Sam Hudson.

The ability to take Rotary Chicken Barbeque dinners home, rather than eat them in Kellogg Park, was first offered in 1962. In 1974, the Rotary Club made it even easier to pick up dinners to eat elsewhere when it set up a carryout location at the corner of Ann Arbor and Lilley Roads. This ad appeared in the Plymouth *Community Crier* on September 4, 1974.

SUNDAY, SEPTEMBER 8th

PLYMOUTH FALL FESTIVAL ROTARY

CHICKEN BAR-B-QUE

Carryout Service

ANN ARBOR ROAD AT LILLY ROAD

"To serve those who do not wish to park in Plymouth but do want to take your Rotary Chicken home."

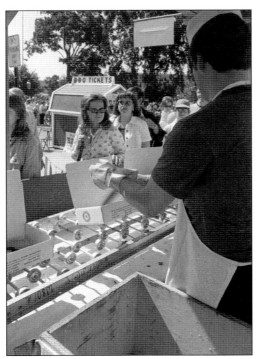

Beginning in the mid-1970s, the carryout containers used by Rotary during the chicken barbeque were printed with Rotary International's logo as well as a list of those who benefitted from the fundraiser. Also during that time period, Rotary members built huts to sell tickets, as seen here in the background. These huts were lovingly referred to as the "doghouse."

In 1977, the Rotary Club changed the off-site carryout location to the corner of Sheldon and Ann Arbor Roads. The "Plymouth Rotary Club Chicken Take Out Express" van was used to ferry completed meal boxes from the assembly area near Kellogg Park to the new pickup spot. Robert Sparling was the chairman of the Carryout Committee.

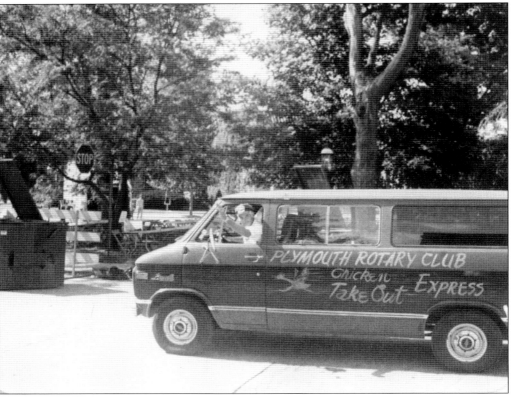

Corn continued to be boiled using the Bunyea steam engine in 1979. What had been added, however, was the much longer stainless steel trough allowing for multiple baskets of corn to cook simultaneously. Volunteers from the Plymouth Salem High School swim team filled many positions throughout the labor-intensive event. Chicken dinner sales surpassed 16,000 this year.

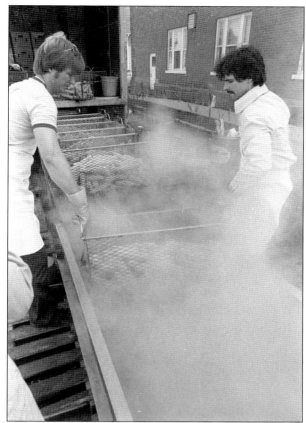

The setup for the chicken dinner continued to evolve over the years. This photograph from 1981 shows multiple lines to help facilitate a speedier distribution. The grilling process incorporated two 80-foot pits allowing for 2,400 chickens to be cooked per hour as compared to 500 per hour during the first event in 1956. Tickets for the dinner cost $4 in 1981, and Eddie Olson served as the event chairman.

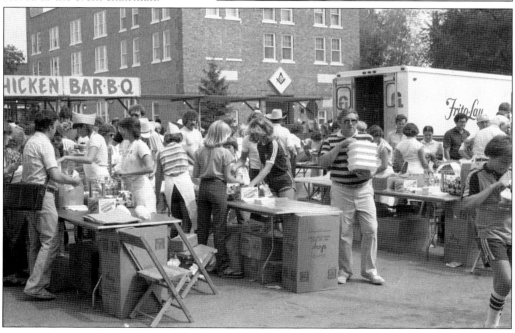

69

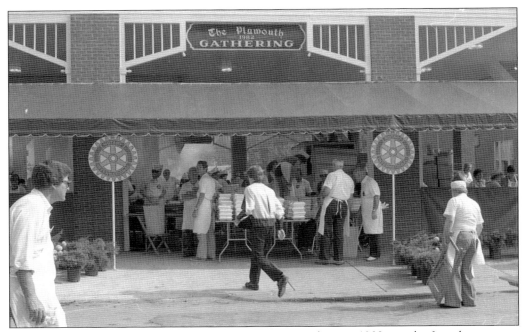

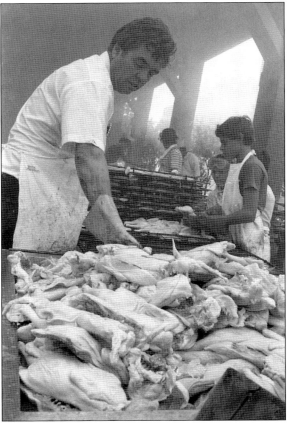

The year 1982 was the first that a permanently covered space was available for the preparation of the chicken dinner. The Gathering proved to be a valuable asset but also presented interesting challenges. They still prepped the chicken and corn, cooked both, and packaged the dinners in the same area. The pavilion was helpful if weather conditions were unfavorable, but it trapped smoke. Air quality in the confined space was an issue.

The racks of chicken were placed bone-side down with the hinge of the rack positioned toward the rear of the pit. While this might seem an arbitrary step, it was important so that as the racks were flipped and moved down the pit, the chicken would be removed from the rack with the bone side down. This prevented the loss of wings and drumsticks by not allowing them to stick to the rack.

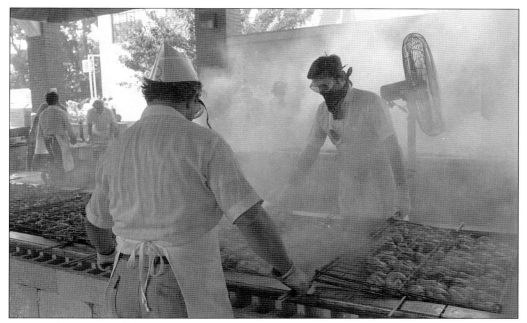

During the inaugural year of the Gathering in 1982, ventilation was an issue even with the large fans that were brought in to help mitigate the smoke. These stalwart Rotarians did not let challenges disrupt their mission to produce thousands of chicken dinners. The use of gas instead of charcoal was considered to help reduce the amount of smoke being produced, but that idea was never implemented.

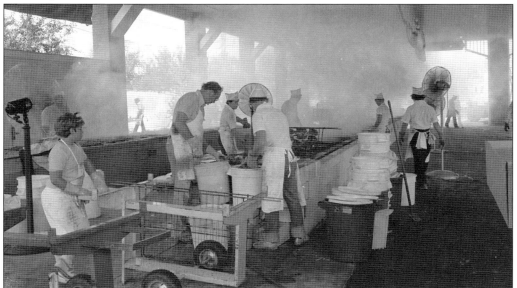

The end of the pit can be seen here in 1982. The expertise of the volunteers at this point was extremely important. Before the cooked chicken was transported to the assembly line, it needed to be tested to be sure it was cooked sufficiently. The thoroughness of cooking was determined by the ease with which the drumstick bone came loose from the meat with the bone separating at the joint.

71

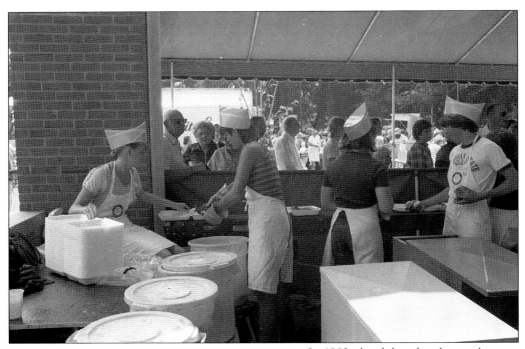

In 1982, the club ordered enough provisions to prepare 15,000 meals. Once the chicken was cooked, it was loaded into buckets that were covered and transferred to the assembly line located at the Penniman Avenue side of the Gathering. A conveyor belt assisted volunteers in efficiently filling the meal containers. Volunteers from the high school swim teams, Boy Scout troops, and the thespian troupe were essential to the successful event.

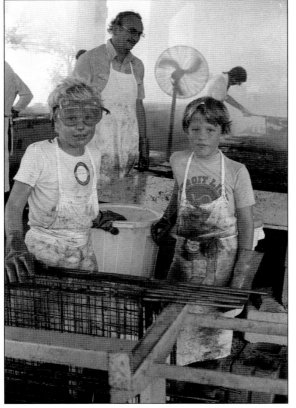

While young volunteers were not allowed to work the pits, they were still helpful with other tasks. These two young men moved the grilling racks after the cooked chicken was removed. They loaded up the cart, which appears in front of them, and transported it back to the area where the racks could be reloaded with raw chicken. More than 160 volunteers helped during the 1982 event.

ROTARY CLUB OF PLYMOUTH
FAMOUS ANNUAL
CHICKEN BAR-B-CUE
SUNDAY, SEPTEMBER 8, 1985

CHARCOAL BROILED CHICKEN DINNER

KELLOGG PARK
Downtown
PLYMOUTH, MICH.

FOR THE BENEFIT OF MANY CIVIC PROJECTS

$4.50
Tax Included

12:00 TO 6:00 P.M.

N⁰ __ 2784

In 1985, the ticket price for the dinner was increased by 50¢ as compared to the previous year. The Rotary Club also offered ice cream and extra drinks for 25¢ each. Rotarians were encouraged to presell tickets and were also assigned to man the "doghouse" during the festival to offer a convenient ticket-buying option and encourage last-minute sales. Ed Schulz was the chairman of the event.

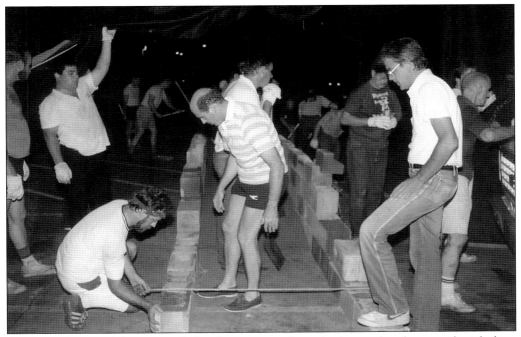

The construction of the pits needed to be precise and required many hands to get the job done efficiently. Careful measuring was necessary to ensure that the racks would fit perfectly and allow the line to run smoothly. By 1985, one pit was located under the Gathering, and the second was in the parking lot. John Folino (left) can be seen holding up the curtain while the blocks were placed.

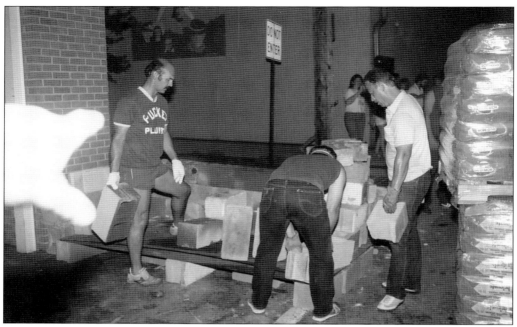

Keeping the coals hot in the pits during the cooking process was an issue. In 1985, a preheat team was formed to construct an area where coals could be kept hot and transferred to the pits as needed. This allowed for a more consistent cooking temperature throughout the day. Barry Simescu (left) assisted in getting the preheat station set up on the parking lot side of the Gathering.

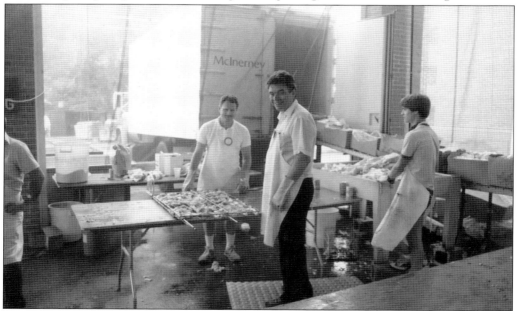

The chicken was removed from the truck and prepared for grilling. To aid in efficiency, for a short time the club ordered only the right side of the chicken because half-chickens of the same side fit together better. In 1985, about 7 tons of chicken, 100 pounds of salt, 18 pounds of paprika, and 12 pounds of black pepper were used to prepare 10,000 meals.

The off-site location set up in the bank parking lot on the southwest corner of Ann Arbor and Sheldon Roads was very popular. Patrons waited in line in their vehicles and easily picked up their dinners without having to deal with the congestion in downtown Plymouth. About one-third of the dinners purchased in 1985 were obtained from this location.

In 1987, a logo redesign contest was held at the two Centennial Educational Park high schools. More than 60 entries were submitted with Josh Worth, a Canton High School student, winning the $100 prize presented by Rotarian Larry Olson. The whimsical design depicted a chicken wearing a chef's hat and a Rotary apron. The logo went to print right away and was included on the poster attached to the ticket barn.

75

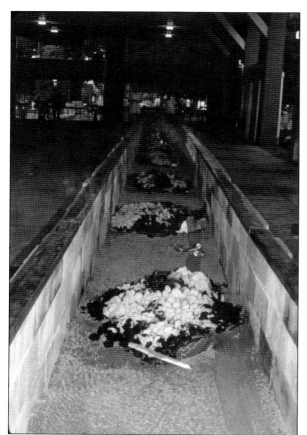

The pit in the Gathering was ready to go after being built the previous day. A layer of sand provided a supportive base for the piles of charcoal bags that were ignited at about 8:00 a.m. on Sunday, September 6, 1987. As the coals heated up, they were spread out to provide an even cooking surface. The first racks of chicken went on the pit about two hours later.

In 1989, John Folino was the chairman of the chicken dinner. Presale tickets sold for $5, with 8,000 being snatched up before the price increased to $6 on Sunday. Volunteers can be seen here assembling thousands of boxes that would eventually house the delicious barbeque dinners. The boxes, printed with sponsors' names and logos, were another unique way for the club to fundraise.

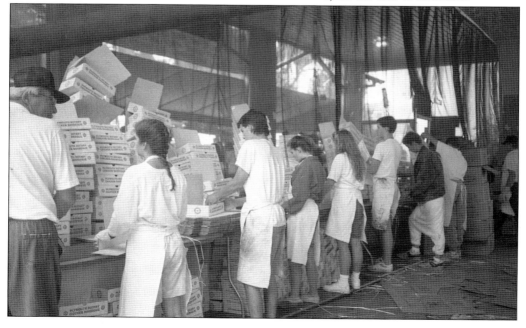

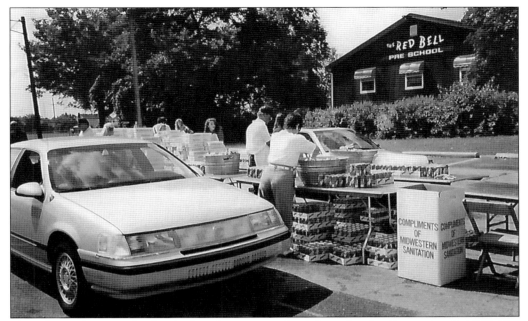

The take-out location for the chicken dinner moved north on Sunday, September 9, 1990. The rear parking lot at West Middle School, on the southwest corner of Sheldon Road and Ann Arbor Trail, was less congested than the previous site and allowed for a longer queue. Large buckets filled with ice helped to keep the beverages cold, and volunteers had a ready supply of dinner boxes to fulfill orders efficiently.

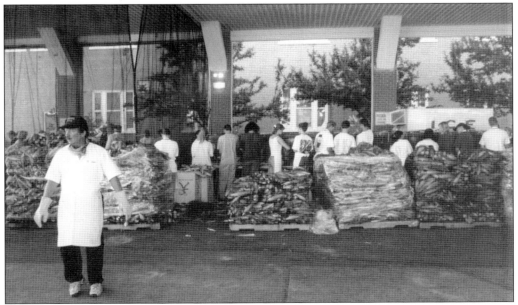

Mark Baldwin was the chairman of the chicken barbeque in 1997 and was probably wondering what Dale Knab (left) was doing near the corn processing area. Knab was part of the pit crew and worked his first barbeque in 1980 before he joined the Rotary Club. Knab has been a devoted Rotarian ever since and has worked, as of 2023, for more than 40 years on the west pit.

77

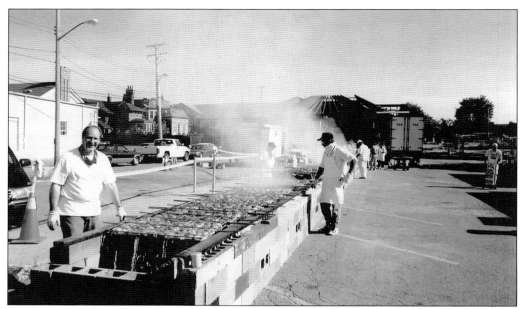

In 1997, the pits were 90 feet long and 36 inches wide. After the cinder blocks were in place, 8 inches of sand was poured into the base. The base was then covered with 5,000 pounds of charcoal. Thirty chicken racks were placed on the pits and attended by 20–30 volunteers, who flipped the racks every few minutes. It took 60–70 minutes for the racks to move down the line.

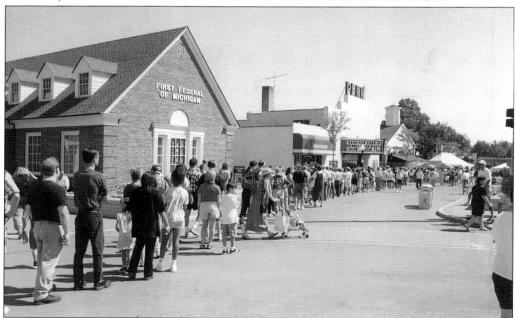

Elizabeth Galea, chairperson of the chicken dinner in 1998, was surely pleased with this queue that stretched to Main Street. The cost of the dinner, which remained the same since 1995, was $7 presale and $8 on Sunday. In past years, the chicken was procured from numerous vendors. In 1998, Plymouth Marketplace won the bid as the sole supplier. An estimated 400 volunteers helped to make the event a success.

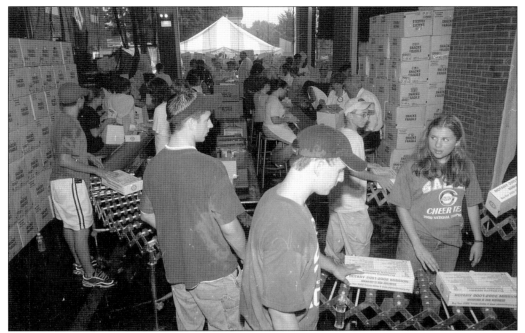

September 9, 2001, was a rainy day. The busy assembly lines can be seen under the shelter of the Gathering preparing 10,579 dinners that were cooked by the teams led by chairman Larry Turner. A new canopy system came in handy that year and allowed for cooking to continue even though the weather was not favorable. In 2001, takeout was available at East and West Middle Schools.

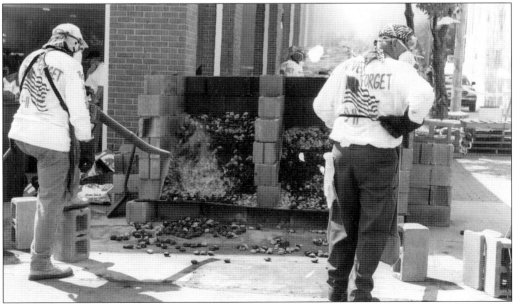

The world changed forever on September 11, 2001. As the nation began to heal, Americans vowed to never forget the tragedy that took place on that fateful day. The preheat team in 2002 honored the memory of those lost in the tragedy with "Never Forget 9/11" printed on the backs of their shirts along with the image of an American flag.

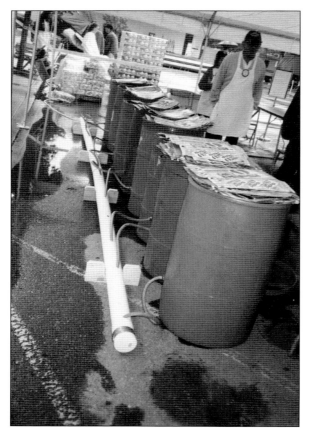

In 2003, Tim Joy was the chairman of the chicken barbeque. The dinners sold for $9 on Sunday. About 11,000 meals were prepared that year with each meal including a beverage. The system of barrels seen here was devised in the 1990s to keep the cans of pop cold. The barrels were filled with ice, and as the ice melted, it was drained to the pipe seen on the left.

By 2005, both pits were located outside of the Gathering. The preheat team can be seen here replenishing the coals to keep an even cooking temperature. A skid steer was used to safely transport the hot coals to the side of the pit. Jan Eisen was the chairman of the barbeque in 2005. The meals sold for $10 on Sunday with a $1 discount on presale tickets. (Photograph by Bill Bresler.)

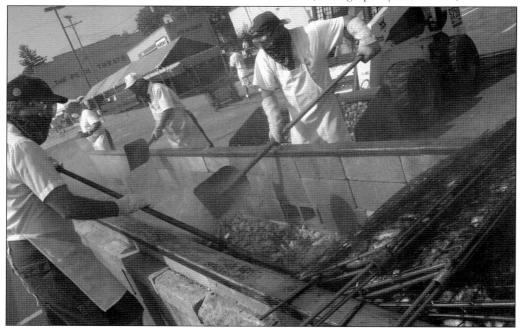

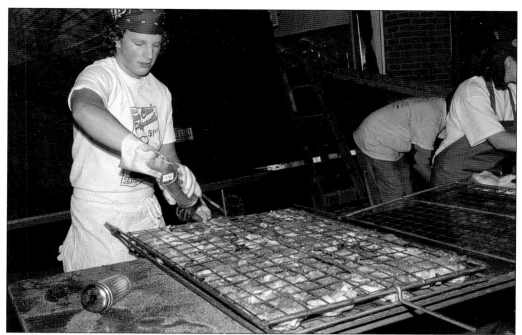

A student volunteer covered the uncooked chicken halves with the secret spice mix that makes the chicken so delicious. In 2006, the club cooked 10,599 halves on 260 feet of charcoal pits. Linda Jones was the chair of the BBQ that year and ensured her committee kept up the standards established over the previous 49 years.

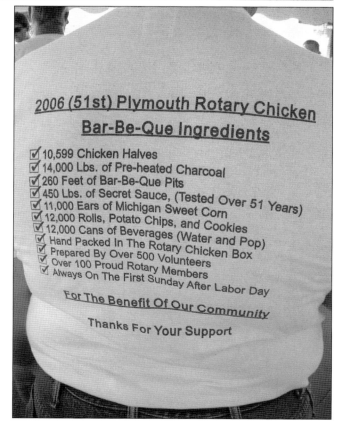

The shirts worn by volunteers in 2007 bragged about the ingredients that made the 2006 Rotary Chicken Barbeque so successful. The 2007 BBQ chair, Howard Oldford, and his legion of club members and volunteers cooked and sold all of the 10,599 chicken dinners before closing time. Tickets sold for $9 in advance and $10 the day of the BBQ.

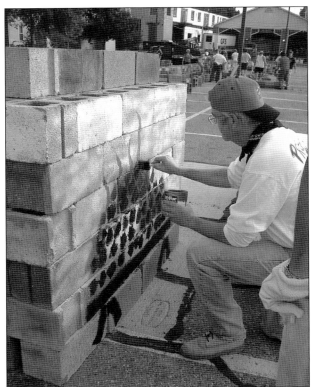

In 2007, preheat chairman Rotarian Ron Lowe got creative by painting the preheat pits with black coal burning to signify the importance and independence of the preheat crew. Except for the initial startup when coal is first lit in the two long pits, the preheat pits were where cold, black charcoal was turned into white hot coals.

Rain presented a challenge in 2008. The west pit had fire a-blazing (right), while charcoal was just being laid in the east pit. Cam Miller was the 2008 chairman and introduced staggered cooking times to prevent the chicken from becoming too tender while it sat in the buckets waiting to be boxed. The last chicken came off the grill at 4:00 p.m., and 10,600 dinners were sold by 5:42 p.m.

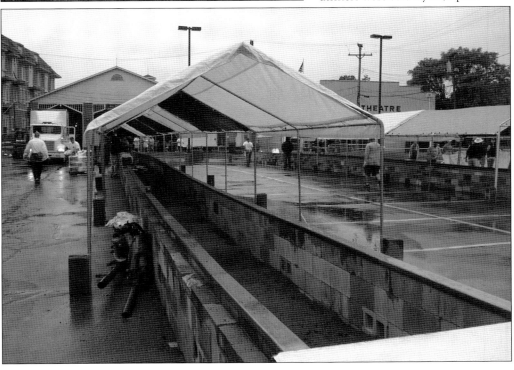

Dan Smith (left) and Kirk Kohn stood guard at one of the 110-foot pits in 2011. They added a secret spice mix before sending the chickens down the line. Kay Linville was "Mother Clucker" of the barbeque that year. The dinner tickets were $10 presale and $12 on Sunday. With the assistance of about 850 volunteers, the Rotary Club sold all 10,500 chicken dinners that were prepared. (Photograph by Bill Bresler.)

The location of the preheat was eventually moved away from the Gathering. An eight-inch-thick concrete slab was installed because the asphalt could not handle the intense heat. Cinder blocks were set on the concrete, and sand was added to the space. A half-inch metal plate was used as a base for the coals. This 2011 photograph shows members of the preheat team wearing firefighting protective gear. (Photograph by Helen Yancy.)

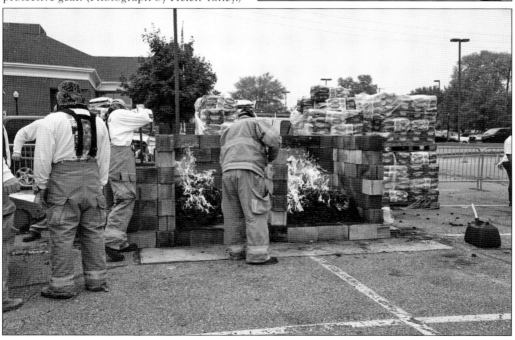

83

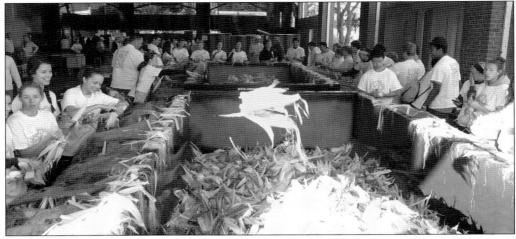

In 2012, volunteers surrounded two large dumpsters that were in the Gathering; they worked tirelessly until all the corn was ready to be steamed. Paul Denski had these dumpsters made exclusively for Rotary corn shucking. Scott Wirgau was the chairman of the event in 2012 and set his sights on the goal of selling all 11,000 dinners that were prepared. (Photograph by Jim Karolyi.)

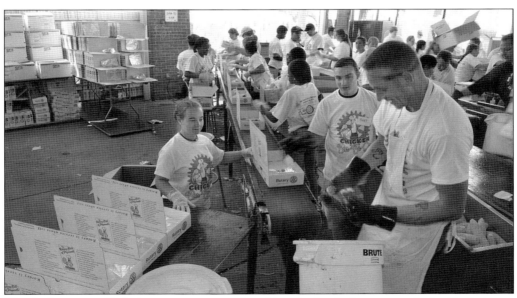

The chicken was grilled, the corn was steamed, and hundreds of volunteers worked with chairman Mike Sullivan in 2014 to get more than 10,000 dinner boxes filled. The boxes were unique and purposefully designed with a slot to hold a beverage. The boxes also presented an exceptional fundraising opportunity with the premium sponsor paying $5,000 to have their logo printed on the inside cover. (Photograph by Bill Bresler.)

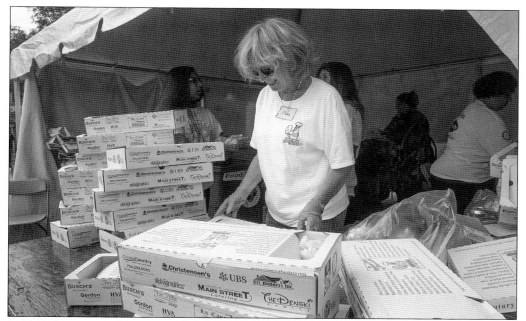

In 2017, chairman Rich Eisiminger and his committee introduced waste recycling as a new component of the barbeque dinner. Volunteer Mary Tomlin was part of the team that helped with this task. The plan also included sorting the napkins, plastic utensils, corncobs, and even the chicken bones. Instead of sending the corncobs and chicken bones to the landfill, they were turned into fertilizer. (Photograph by Bill Bresler.)

In 2017, Marie Morrow worked in the Gathering unpacking boxes of rolls supplied by Gordon Food Service. This is much different than what took place in 1978. That year, dinner rolls were supplied by Terry's Bakery on Ann Arbor Trail. Howard Wendel and his sons mixed up 800 pounds of dough and spent 10 hours the day before the chicken dinner baking 1,400 dozen rolls. (Photograph by Helen Yancy.)

Fall Festival was canceled in 2020 because of the COVID-19 pandemic. In 2021, the Rotary Club of Plymouth worked hard to rebuild public interest in the annual chicken barbeque. Brandon Bunt, chair of the BBQ that year, donned an inflatable chicken outfit and walked the streets of the Fall Festival craft show to gain attention, along with Rotarian Jason Zarate (left) and Najeeb Haddad (center). (Photograph by Liz Kerstens.)

Fall Festival and the Rotary Club's chicken BBQ returned in full force in 2021, with sanitary protocols observed by everyone involved in the event. On Saturday, September 11, the club was feverishly preparing for the next day's event, including 47 volunteers from Plymouth Cheer. The group assembled 8,980 take-out boxes in 3.5 hours, or about a box per person per minute. (Photograph by Paul Sincock.)

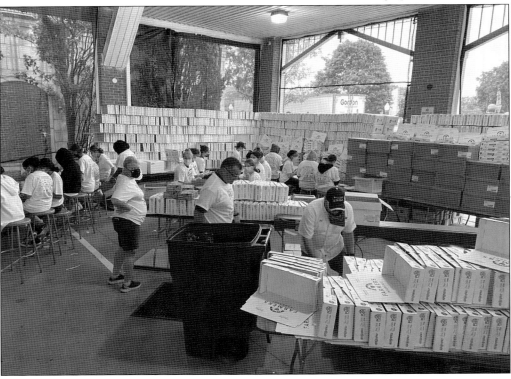

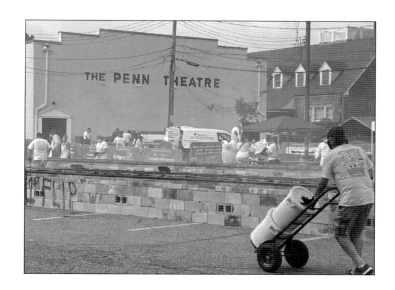

Years of barbecuing chicken has left the Plymouth Rotary Club with scores of lessons learned. One of those lessons was spray-painted on the cinder blocks of the BBQ pit in 2021. "1st Flip" is the spot where the grillers need to turn the racks over for the first time. The charcoal heat intensity determines how many other turns are needed to cook the chicken properly. (Photograph by Paul Sincock.)

Rotary Youth Exchange students from around the world, representing two Rotary districts, were invited by the Plymouth Rotary Club to enjoy the chicken barbeque in 2022. The flags shown represent the countries that the students came from. The Rotary Club supports the Youth Exchange Program, which is part of the US government's foreign policy to promote goodwill and understanding between countries. (Photograph by Bill Bresler.)

The perfect chicken is taken off the grill when its temperature ranges between 165 and 180 degrees. This rack of chicken was checked with a meat thermometer during the 2022 Rotary Chicken Barbeque. "Head Cluck" Gary Stolz and his crew served up 8,672 chicken dinners that day. (Photograph by Bill Bresler.)

Approximately 725 volunteers checked into the volunteer tents near the BBQ pits during the 2022 Plymouth Rotary Club Chicken Barbeque. While Rotarian Gary Stolz was the chairman of the event, he did double duty as the volunteer coordinator with assistance from other committee members. An event of this magnitude required help from many volunteer groups. (Photograph by Helen Yancy.)

September 10, 2023, was the 66th time that the Rotary Club prepared a chicken dinner for the community. From the advent of the meal in 1956 there were two years, 1959 and 2020, that the event did not take place. Andy Savage was "Chief Cluck" in 2023. An innovation for this year was the opportunity for patrons to purchase tickets online using a QR code. This was a helpful tool to keep the line moving at the drive-through location at West Middle School. Volunteer check-in also utilized a QR code to effectively organize the hundreds of participants from different local service clubs and schools. The concept of preselling tickets online began a few years before, and about 200 e-tickets were sold as of September 8, 2023, for the dinner that year. Over the years, the Rotarians have proven to be very resourceful in their use of technology to improve the efficiency of the process of producing thousands of dinners for their loyal patrons.

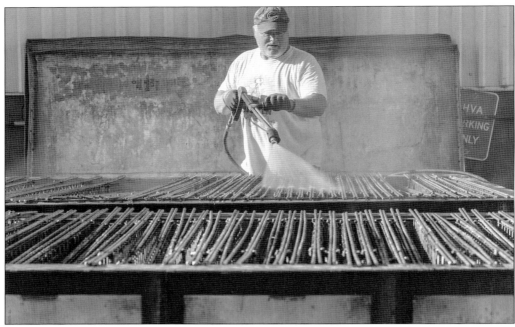
After each year's chicken barbeque, two containers of used grilling racks are stored in the yard of the City of Plymouth's Department of Municipal Services. For about a week before the scheduled rack cleaning, Rotary's steam machine is used to loosen debris in preparation for the steam spray that Rotarian Terence Durkin applied in August 2023. (Photograph by Pete Mundt.)

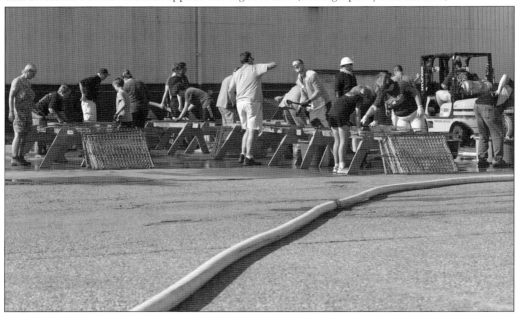
Rotary Club members brought family and friends to help clean the 135 racks destined to be used to cook chicken during the 2023 Fall Festival. About 100 hearty souls wielded long-handled four-inch brushes dripping with detergent to scrub each presoaked folding rack. The racks are made of very high-quality stainless steel purchased by the club in 2008. (Photograph by Pete Mundt.)

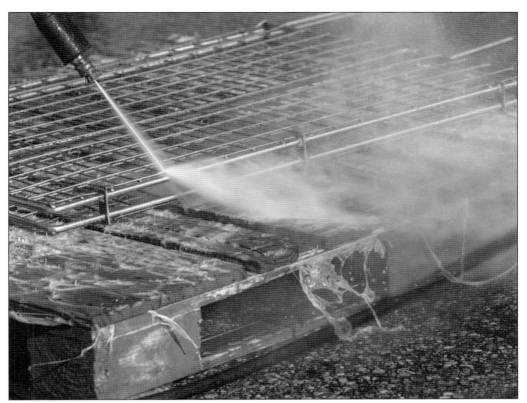

The final step in the rack cleaning process was a super rinse with a high-pressure spray of plain water. The sparkling clean racks were then returned to the stainless steel holding cart to await the big day. On the Thursday before the BBQ, the carts were carried over to the set-up area. (Photograph by Pete Mundt.)

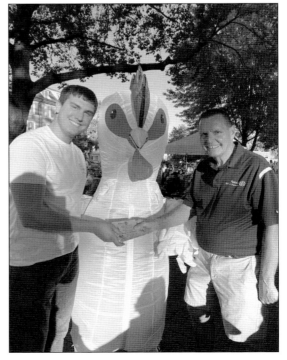

After receiving a Rotary pardon on September 1, 2023, chicken Doug Willett (center) set off with Chuck Lang (right) during the concert in Kellogg Park to sell tickets for the barbeque dinner. It did not take long before Nate Griwicki (left) stepped up as their first customer. The chicken and Lang traveled through the park and provided a unique photo opportunity for happy concertgoers. (Photograph by Ellen Elliott.)

The week leading up to the chicken barbeque was busy. On Thursday, September 7, 2023, the secret spices were combined at the Mama Mucci's Pasta plant located at 7676 Rhonda Drive in Canton, Michigan. Andy Savage (left) helped as Doug Willett poured 50 pounds of paprika into the hopper. Two other ingredients were added, and the mixing began. (Photograph by Pete Mundt.)

After the spices were perfectly blended, Andy Savage (left) and Todd Raska scooped the concoction into the buckets while Doug Willett looked on. When all the ingredients were mixed and packaged, 12 five-gallon buckets were loaded onto Raska's truck and awaited transport to the cooking site in downtown Plymouth. The process of combining and packaging the seasonings took less than an hour. (Photograph by Pete Mundt.)

Set up for the barbeque began on Saturday, September 9, 2023. Volunteers were scheduled in shifts to ensure that all the tasks for the day were completed. The able-bodied students from the Canton High School football team assisted in setting up the pits. The sand in the east pit was being leveled before the charcoal was placed. (Photograph by Pete Mundt.)

The Gathering was divided into four distinct preparation areas. The boiler is seen here on the east side, where the corn was cooked in the large vat. Beyond the screening to the south, the packaging area was staged. The other two spaces not seen in this photograph are the chicken prep area draped off toward the north and the corn-shucking space to the west. (Photograph by Ellen Elliott.)

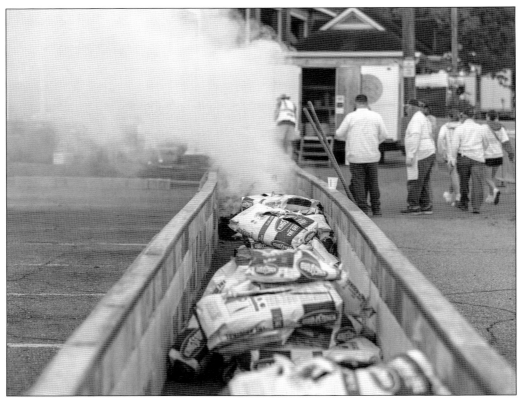

On the morning of Sunday, September 10, 2023, charcoal was placed in the center of the west pit—100 bags divided into 10 piles equally spaced along the 90-foot expanse. Dale Knab, leader of the west pit, preferred to have ventilation blocks spaced at five-block intervals as opposed to the seven-block spacing used by the east pit. The west pit charcoal was lit at 8:00 a.m. (Photograph by Pete Mundt.)

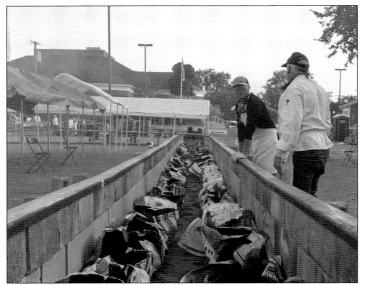

Cam Miller, chief of the east pit, had a different philosophy about how the pit needed to be set up for the best grilling environment. He started with the charcoal being laid along both edges of the block to provide what he called a "convection heat." He was assisted by volunteer Conner Stella (left) as they got ready to light the coals at 8:30 a.m. (Photograph by Pete Mundt.)

In the past, the chicken dinner had ice cream as a dessert option. Keeping the ice cream frozen presented a challenge, so another type of sweet treat was considered. Cookies were an easy choice and were eventually included in every chicken dinner box. Volunteers individually wrapped each cookie before it was carefully sent down the packaging line. (Photograph by Pete Mundt.)

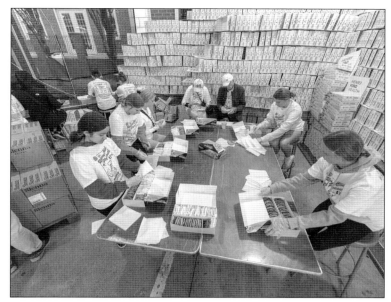

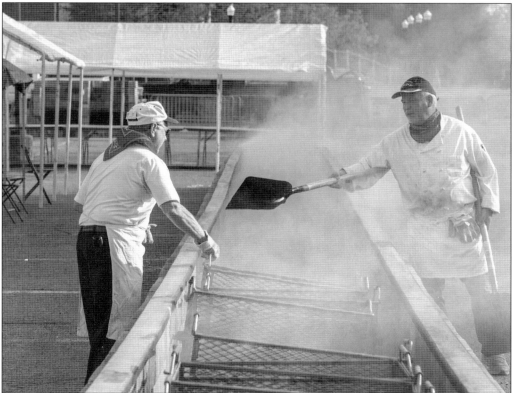

Kirk Kohn (left) and Cam Miller worked on the east pit. As the coals heated up, the corn cooking baskets were placed in the pit to burn off remnants of last year's cornsilk. Envious of the west pit shovels, Miller was on a quest to find perfect implements of his own. He perused many options before happening upon smaller scoop shovels with sides and long handles. (Photograph by Pete Mundt.)

While the pits and the Gathering were being set up to prepare the chicken dinner, Kellogg Park needed to be transformed into a large picnic area. John Segura, from the Department of Municipal Services, along with help from many student volunteers, quickly set up tables and chairs for hungry diners to sit under the shady tree canopy to enjoy their meals. (Photograph by Pete Mundt.)

Rotarian Ron Lowe, second from left, was recovering from a lengthy hospital stay in September 2023 but still showed up to supervise pre-heat activities on the day of the BBQ. Members of his crew, from left to right, included Rotarian Jason Zarate, James Rodgers, and Greg Baack. (Photograph by Pete Mundt.)

Student volunteers removed the silk threads left by corn husks and placed the corn in baskets as the final step before the corn was cooked by the steam machine at the end of the line. Sanitizing sinks for cleaning used chicken buckets can be seen on the left. (Photograph by Pete Mundt.)

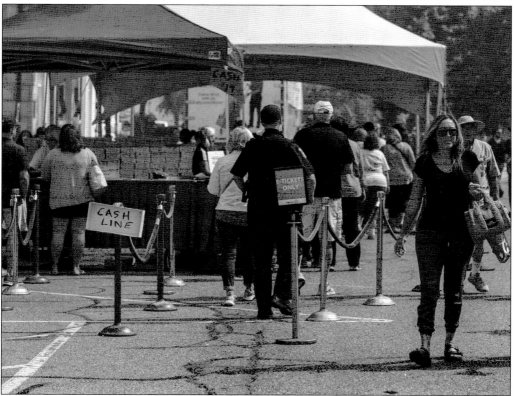

Ticket sales on the day of the 2023 BBQ were brisk. Tickets sold for $17 that day at the tent outside of the Gathering. While cash was accepted, e-tickets available from Rotary's website were an added option with a separate entrance to keep the line moving. (Photograph by Pete Mundt.)

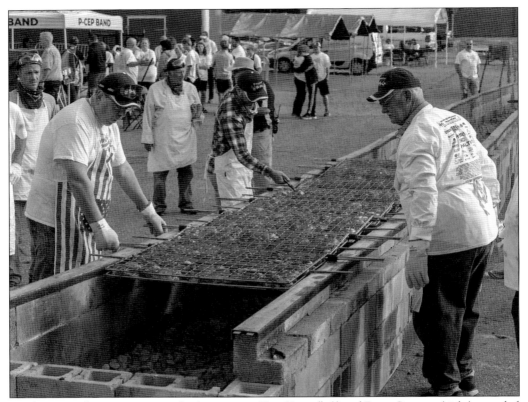

Quality control was important to both pit teams. Kurt Heise (left) and Barry Simescu (right) attended to the chicken that had just been placed on the west pit. Josh Mrozowski (center) carefully inspected the chicken before the racks made their way down the 90-foot stretch. Using pliers, Mrozowski removed any stray quills that were missed when the chicken was in the prep area. (Photograph by Pete Mundt.)

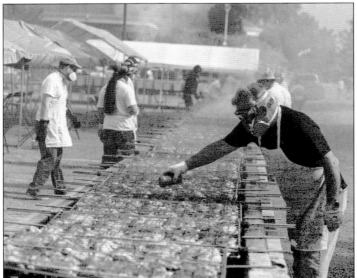

Dedicated volunteer Russ Baltazar, working on the east pit, carefully seasoned the chicken as it began its trip down the pit. The amount of seasoning used and the way the chicken was cooked differed between the pits. The east pit cooked slower and longer and used light seasoning, as the chicken would burn if too much of the secret spice mix was added. (Photograph by Pete Mundt.)

This bird's-eye view shows the final stage of one of the three packaging lines where boxes were filled with delicious contents before sending them on conveyor belts to the distribution points. The boxes were packed in one of the four preparation areas and exited through barrier flaps on their journey. (Photograph by Bill Bresler.)

The drive-through at West Middle School was bustling with activity as ticket holders swiftly made their way to pick up their delicious chicken dinners; even the paramedics from Huron Valley Ambulance stopped by. Nancy Baldwin led the team that provided superior service for the diners who wanted to avoid the crowds in Kellogg Park. (Photograph by Pete Mundt.)

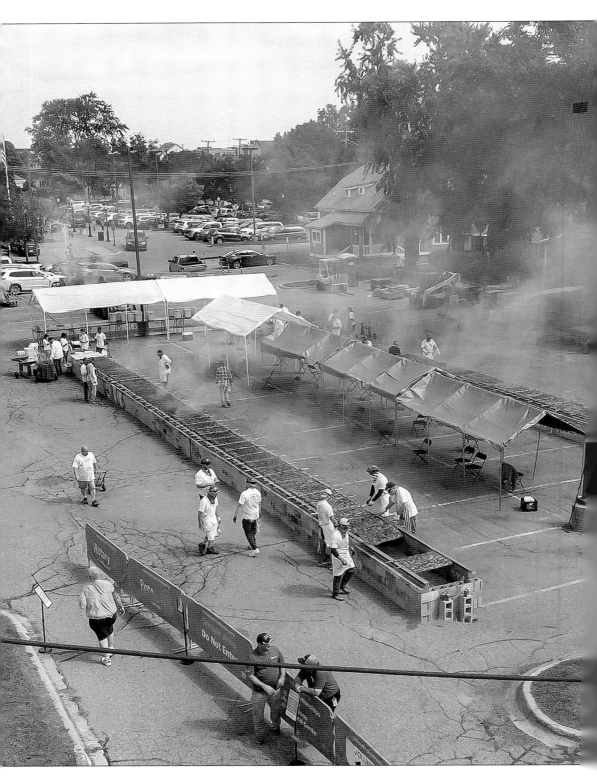

A panoramic view from the roof of the Penn Theatre shows the west (left) and east pits situated in the parking lot behind the Gathering. The pits were fully lined with racks of chicken, smoke filled the air, and the Rotarians and volunteers were hard at work. The chicken came off the racks at the far end of the pits. Buckets for chicken transport were placed on tables under the two white tents located perpendicular to the pits. The preheat zone was conveniently positioned just beyond these tents. The covered section between the pits contained chairs for quick rests and hydration breaks for tired crew members. The entire area was cordoned off with barricades to keep passersby at a safe distance from the fiery heat. A total of 8,175 chickens were cooked on this day. (Photograph by Pete Mundt.)

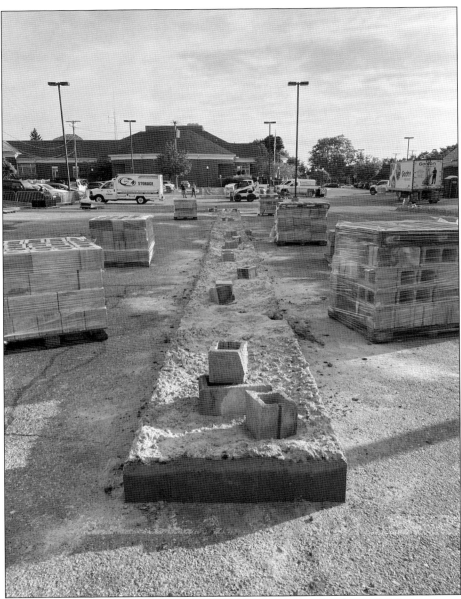

On Monday, September 11, 2023, as the sun was rising on another beautiful day in downtown Plymouth, a faithful band of Rotarians came out to finish cleaning up after hosting a successful chicken barbeque. The semitruck arrived, and a busy hive of volunteers and crew from Serene Surroundings landscaping company got to work loading the equipment that was necessary to package meals for thousands of hungry diners, including conveyor belts, corn carts, corn baskets, dollies, signage, stools, stanchions, and containers used to hold the corn after it was shucked. The pits were disassembled, and the salvageable blocks were loaded onto pallets and wrapped. The pallets were transported back to the storage yard awaiting the next year's event. With the smell of smoke still in the air, smoldering ashes lay in the west pit atop a bed of sand as it all cooled down, thus closing the chapter on another fruitful year for the Rotary Chicken Barbeque. Chairman Andy Savage and his crew deserved accolades for a job well done. (Photograph by Ellen Elliott.)

Seven

TRADITIONS

The Rotary Club of Plymouth is steeped in tradition. Within the first 10 years of the club's founding, members' birthdays were acknowledged with the presentation of a rose. While the tradition of the rose faded away, birthdays are still recognized during membership meetings. Early on, the club's sergeant-at-arms would fine members for various light-hearted infractions, such as putting the wrong date on a meeting make-up card.

As far as barbeque traditions are concerned, there are a plethora. Beginning in 1988, the ceremony known as the "State of the Barbie" formally recognized the new advisor to the BBQ, who is the immediate past chair and supervisor of the refreshment area, now known as the "Magic Kingdom." In the formal ceremony a stick, known to some as the "wand of wisdom" or the "staff of knowledge," is given to the new advisor, with the following words of advice: hold this staff close, very close; sleep with the staff under your pillow; don't let anyone touch, hold, or look at the staff; consider using a decoy staff when out in public; don't break the staff; don't let the staff go to your head; don't leave the staff in your car, it will get stolen; and don't let the staff out of your sight.

An example of good-natured fun appeared in 1992, when the September 4 *Broadcaster* of the Rotary Club of Plymouth declared, "Chief of all the Chicken Workers, Hal Cooper was formally presented with his cap pronouncing him to be King Cluck of Sunday the 13th and a truly unflappable King he proved to be through the tribulations of barbeque Sunday." It went on to state, "Any members who had not appeared for the set up on Thursday or who had not been accepted for the duties of Guardian of Inside Pit, Outside Pit, or Server of the Fires of Pre-Heat found themselves relieved of some of the pecuniary contents of their purses."

Another of the ongoing traditions is the rivalry between the two barbeque pits. That rivalry still exists, and it is yet to be determined which cooks the better chicken.

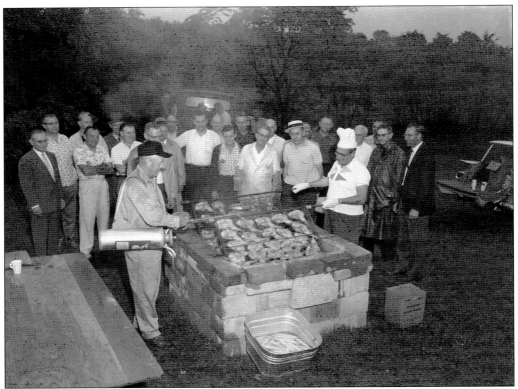

On August 16, 1962, the Plymouth Rotary Club began a long tradition of holding a "Dry Run" of the barbecuing process before the big day. The Chef's Committee, including Don Lightfoot and Cliff Tait, wanted to test the new grills designed by Rotarian Frank Arlen that sandwiched the chicken while it cooked. The event was held at Tait's residence in Plymouth Township. Rotary Club members participated in the trial feast.

Over the years, the Dry Run also became an opportunity to have a Rotary golf outing. On August 29, 2019, the event was held at Fox Hills Golf and Banquet Center just west of Plymouth. Club camaraderie is a goal, as demonstrated by Rotarians, from left to right, James Gietzen, Dan Amos, and Chris Porman holding up president-elect John Buzuvis. (Photograph by Helen Yancy.)

One of the rules of the Dry Run Rotary golf outing is that golfers cannot use a club on the green on the 18th, or last, hole. During the 2019 event, Brandon Bunt prepared to putt using the only authorized tool on that hole—a pool cue without a tip.

In 2008, the Wand of Wisdom was missing, and ransom was demanded by the Chicken Little Liberation Army; even Plymouth police chief Wayne Carroll was unsuccessful in the quest to rescue the wand. On Friday, September 5, 2008, two members of the Kiwanian SWAT team, Jim Grutza (left) and Dave Latawiec, saved the day when they heroically returned the Wand of Wisdom to Rotary Club president Nancy Baldwin.

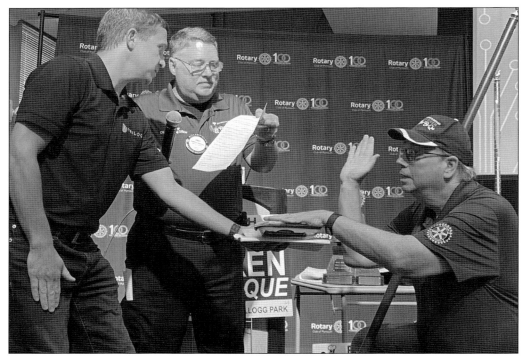

The State of the Barbie took place on August 25, 2023, with Brandon Bunt (left), installing Gary Stolz (right) as the advisor to the "Bar-Be." Chairman Andy Savage (middle) looks on as a new Staff of Knowledge is bestowed. Stolz valiantly took the oath with his hand placed on the frozen Breast of Truth, thus beginning his rule over the Magic Kingdom. (Photograph by Ellen Elliott.)

The Staff of Knowledge is the symbol of authority given to the advisor to the Bar-Be. It is nefariously sought after and must be protected with vigilance. It is recommended that the advisor sleep with it under his/her pillow and use a decoy when out in public. In 2023, it made its way around Plymouth with one stop at the Plymouth Historical Museum, as seen here. (Photograph by Chuck Lang.)

The Rotary Club was a major sponsor of the Friday night Music in the Air summer concerts. On September 1, 2023, Chuck Lang (left) and Doug Willett, dressed as a chicken, were on stage to encourage people to attend the BBQ. The advent of a new tradition took place when Lang got the brilliant idea to give the chicken a Rotary pardon; the crowd loved it. (Photograph by Ellen Elliott.)

It became a tradition to paint the blocks after the pits were constructed. The pit workers were loyal to the pit that they served, and antics between teams were constant. This 1987 photograph captures the yellow-painted pit, located outside of the Gathering, with a moniker provided most certainly by the members of the other pit. The question of which pit, east or west, produces the best chicken remains unanswered.

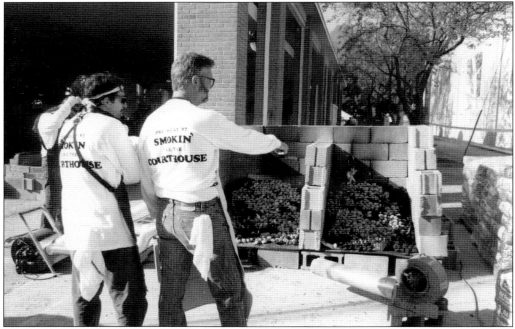

The Plymouth 35th District Court building burned to the ground on July 2, 1997. One of the district judges, Rotarian Ron Lowe (right), was also the chairman of the pre-heat committee. For many years, that committee had unique t-shirts designed for committee members to wear on the day of the BBQ. The 1997 t-shirt design "Smokin' Like the Courthouse" was an homage to Lowe and the fire.

The preheat crew cooks anything but chicken for lunch for the team on the day of the barbeque. A separate grilling pit is built next to the preheat pits, and something exotic is prepared. In 2008, the crew cooked an entire pig and shared the feast with those in the know. Team members are sportsmen and have cooked venison, salmon, and other wild game through the years.

Larry Turner was the BBQ chairman in 2001. After his death in 2003, the Larry Turner Memorial Cup was given to the Rotarian who best evidenced Turner's indomitable spirit. The first award was given to Clifford McClumpha in 2005. In subsequent years, winners included Gary Davis, Bill Morrison, Tom Piotrowski, Jeremy Richardson, Paul Opdyke, Denise King, Gary Stolz, Dan Amos, and Eric Lloyd. It was awarded twice to Barry Simescu.

Each year, the Plymouth Rotary Club's marketing gurus sell ad space to sponsors on the boxes used to hold the chicken dinner contents. In addition, since the mid-1980s, the BBQ chairman's initials and the year have been printed on one side of the box. This box is from 2014; the "MS" indicates Mike Sullivan was the chair that year. Plymouth Packaging made the boxes for Rotary until 2019.

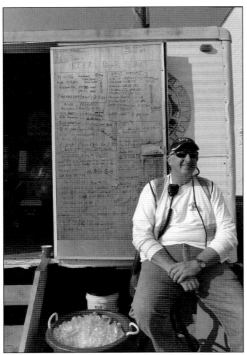

The trailer has been a fixture at the barbeque for many years. It holds a myriad of items, including buckets of secret spice, brooms, and trash bags. In 2017, Dave Batts sat next to the trailer door. He was also in charge of the Dry Run that year and was levied a fine at the August 4, 2017, meeting for scheduling the event on a Thursday. (Photograph by Helen Yancy.)

The club trailer not only houses equipment and supplies but also serves as an archive. Removable panels display data from past events. The information for the September 9, 2001, barbeque, as recorded by chairman Larry Turner, is displayed on the lower corner of the door. The first chicken went on at 8:37 a.m. and was cooked by 9:15 a.m. He also noted rain twice. (Photograph by Pete Mundt.)

On the day of the 1989 Rotary Chicken Barbeque, Bill Taylor (left) and Harold Guenther manned the "doghouse," selling $6 dinner tickets, extra pop for 75¢, extra corn for 50¢, whole pies for $7.50, and a slice of pie for $1.50. Taylor joined the Plymouth Rotary Club in 1966; Guenther joined in 1952.

In 2022, the Plymouth Rotary Club had a separate tent set up to sell pop and distribute extra butter, salt, napkins, utensils, corn, cookies, and bottled water. Pop was no longer offered with the chicken dinners. Rotarian Win Schrader (behind the Coke) manned the tent along with other Rotarians and volunteers. (Photograph by Helen Yancy.)

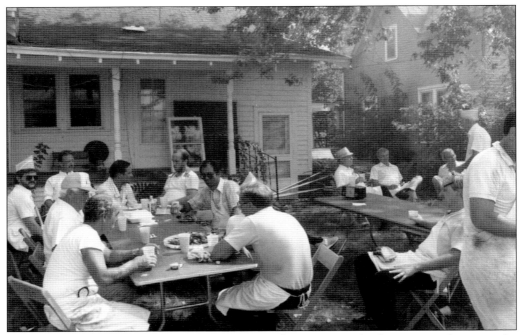

In 1985, after spending hours working the pits, tired Rotarians and volunteers sought rest in the backyard of Glenn Meadows's home at 260 South Union Street. Later known as the Magic Kingdom, the chairperson emeritus was responsible for managing this area and assuring that those working the pits had adequate sustenance and liquid refreshment.

Advisor to the Bar-Be Gary Stolz (right) welcomes, from left to right, Chief Cluck Andy Savage, district governor Russ Jones, and Rotarian Eric Joy to the Magic Kingdom in 2023. The tented refreshment center was moved to this area behind the Wilcox House at 676 Penniman Avenue after the Meadows home on Union Street was sold in 1994. (Photograph by Pete Mundt.)

A long-standing tradition of 64 years was broken when the Plymouth Rotary Club inducted its first female member on August 12, 1988: Sandy Mily. She participated in the chicken BBQ about a month after she joined. Mily is flanked here by Rotarian Ed Quant (left) and John Vos, club president. She was still a member of the club in 2023.

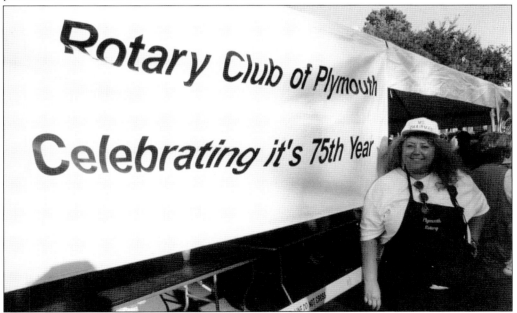

During the 1998–1999 year, the Rotary Club celebrated 75 years of service to the Plymouth community. Ten years after the first woman joined the previously all-male club, Elizabeth Galea served as the first woman chair of the 1998 Rotary Chicken Barbeque. Galea joined the club in 1990. This banner was presented to the club by the Rotary Club of Wayne to display over the Gathering during the BBQ.

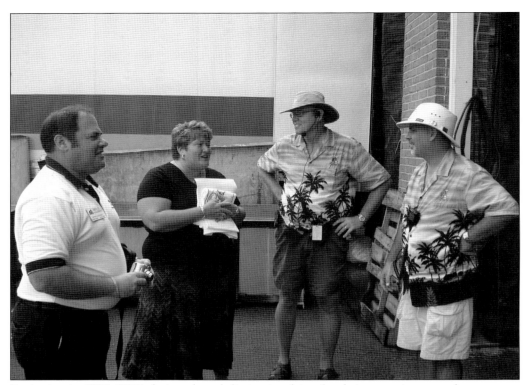

Beginning in 1999, BBQ chairs selected distinctive shirts for their committee members to wear on the day of the event so that people could easily find them. Cam Miller (right), chairman of the 2008 Rotary BBQ, selected a tropical-themed shirt for his committee, including Russ Jones (second from right). Then–district governor Bruce Goldsen (left) and his wife, Sue, visited with Miller and Jones on September 7, 2008.

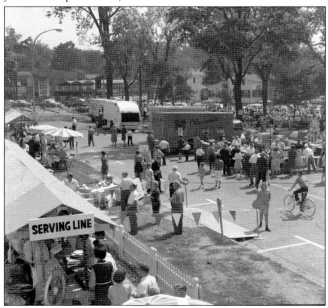

This photograph from 1963 featured the all-important Cloverdale refrigerated truck parked on Penniman Avenue, across the street from where the chicken dinner was prepared. The vehicle not only kept the ice cream frozen but also provided the perfect location for thirsty adult volunteers to take a break from the pits to enjoy an icy-cold sip of Rotary milk. This refreshing beverage came not from a cow but from a brewery.

Eight

COMMUNITY IMPACT

The Rotary Club of Plymouth has supported the community since its inception in 1924. The chicken barbeque gave the club the incentive to ramp up its fundraising objectives. Money raised through the club's activities was used by the Plymouth Rotary Foundation to fulfill its mission. The foundation was established in 1957 to implement the Rotary motto of "Service Above Self."

Charitable groups and community organizations that have benefitted from grants include the Opportunity House, March of Dimes, Salvation Army, Junior Achievement, Special Olympics, Plymouth Community Band, Plymouth Symphony Orchestra, Plymouth Salem swim team, Boy Scouts and Girl Scouts, YMCA, Camp Michi-Mac Asthma Camp, Growth Works, the Plymouth-Canton Substance Abuse Task Force, Plymouth Historical Society, Plymouth Community Council on Aging, Plymouth Family Service, high school band, and Plymouth District Library.

The club's community impact extends beyond giving money. Club members have been involved in a variety of service projects directly affecting the quality of life for residents, including support for Veterans Park, Rotary Park, planting bulbs on Main Street, a local literacy program, and Arbor Day awareness.

To celebrate the Rotary Club's 50th anniversary in November 1973, the Plymouth Rotary Club's Kidney Machine Unit was established with a new machine at St. Mary Hospital in Livonia, Michigan. In March 1974, the club wrote a check for $4,472.65 for a second kidney machine, which allowed the hospital to treat nine cases on a full-time basis as well as numerous outpatient cases.

Through the years, the club has also provided support for Rotary International projects overseas, including a veterinary outpost in Burkina Faso, Africa; the Rotary International PolioPlus Program; support for students in Nicaragua; the Shanta Shawab Nursing School in Kathmandu, Nepal; and establishing a library for health education in Papua New Guinea.

The Plymouth Rotary Foundation has received substantial gifts from Rotarians and estates of Rotarians. These monies are placed in a special reserve account to fund scholarship programs. Two specific scholarship funds that have significantly impacted students in the community are the Arthur Haar Memorial Scholarship and the Walter Panse Memorial Scholarship.

The club's fundraising pace continues unabated.

In March 1961, Crippled Children's Committee chairman Herald Hamill (left) and president Sam Hudson visited the Western Wayne County Easter Seal Center in Inkster. They met with the center's executive secretary, Jane Devereaux (second from right), and board of directors member Neva Lovewell. The month-long Easter Seal appeal began on March 2 and included an Easter lily sale conducted by the Plymouth Rotary Anns. The campaign realized more than $2,500 in contributions.

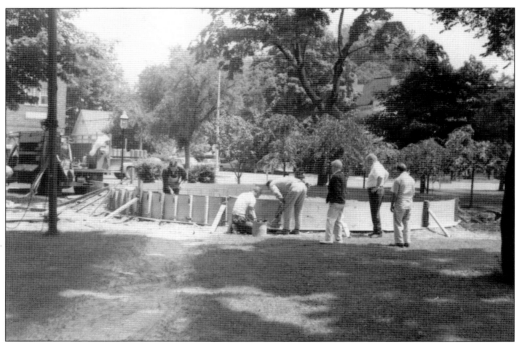

The involvement of the club was critical when the decision was made to significantly transform Kellogg Park in the 1960s. The plan included adding wooden and concrete benches, creating brick pathways, and enhancing the landscape with new trees and shrubs. Plymouth Rock, which had been in place since 1935, was moved, and a water feature was installed. Loren Gould led the group that helped construct the new fountain in 1969.

In 1968, the club donated $5,000 for the installation of a fountain in Kellogg Park as part of a beautification program. The Kiwanis Clubs and the Women's Garden Club participated. Landscaping was added when fountain construction was completed in 1969. The fountain was dedicated later that year by president Bill Covington (right), thus providing the first iteration of one of the most iconic features in downtown. (Photograph by John Gaffield.)

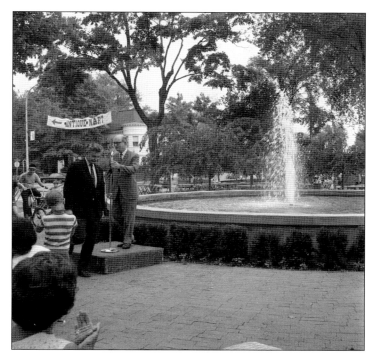

In 1971, the Plymouth Rotary Club pledged $20,000 over a five-year period to restore and upgrade the farm facilities on the Plymouth School Board's property on Joy Road. The area was renamed the Plymouth Rotary School Farm and was used for about a decade to teach rural life skills to students. The facility was closed in 1981.

In April 1974, before the Plymouth Historical Museum was completed and open to the public, a large wall mural depicting Plymouth in 1909 was donated by the Plymouth Rotary Club to mark its 50th anniversary. The mural was replaced in 2009 with the same image in a sturdier format. The updated mural was funded by the Plymouth Rotary Foundation. Student classes learn history through studying the mural.

In 1963, Rotarian Wayne Dunlap, director of the Plymouth Symphony, brought up the idea of purchasing a portable band platform that could be used for concerts and community events. Rotary pledged $1,000 to support the effort. Bob Burr was the conductor of the community band in this photograph from 1978 as it presented a concert in Kellogg Park. This band shell was replaced in 1998. (Photograph by Ken Garner.)

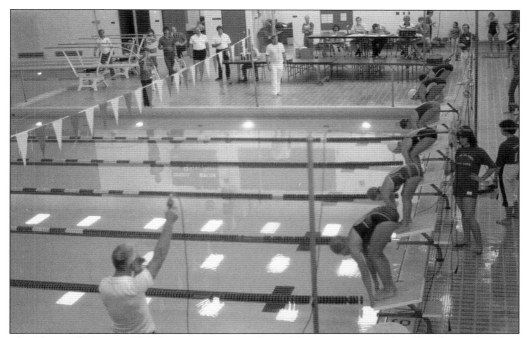

The Plymouth Rotary Club began sponsoring the girls' swim invitational at the Plymouth Salem High School in 1980. It was eventually known as the Rotary Swim Meet. The start of the meet at the Salem pool in September 1981 is shown here. The Plymouth Canton team introduced new girls' swimming coach Hooker Wellman that year. In addition to the Canton team, the Salem, Brighton, and Fordson teams were part of the invitational.

Two Plymouth Salem High School seniors were awarded college scholarships by the Plymouth Rotary Club in June 1985. Rotarian Dale Knab (right) gave Jeff Koslosky and Lisa Curtis checks for $1,500. The club founded its Student Loan Program in November 1945 at the suggestion of the club's first president, George Smith. This became a scholarship fund, and eventually, the Plymouth Rotary Foundation was formed. (Photograph by Cheryl Eberwein.)

Over the years, the Rotary Club and its foundation have supported many civic pursuits; assisting organizations that provide enhancement of arts and culture is commonplace. The community band received support from the Plymouth Rotary Foundation in March 1985. Horn player and Rotarian Sid Disbrow (left) accompanied band director Carl Battishill as he received a $250 check from Rotarian Ed Schulz (right).

As early as 1943, the club provided sponsorship funding to allow local youth to attend the Boys State program. Founded in 1935, Boys State offers participants the opportunity to be immersed in the workings of local, county, and state government. A check was presented on December 18, 1987, in the amount of $350 to the American Legion by Eddie Olson (left) and Hal Cooper (center) in support of this program.

Rotary International declared the 1987–1988 Rotary year the "PolioPlus Year." Local clubs were encouraged to join the fundraising effort to impact the elimination of polio worldwide. The Plymouth Rotary Club participated in the campaign by highlighting it on the 1987 chicken BBQ boxes. In addition, the club held an auction in October that year to benefit PolioPlus. Plymouth's contribution to the campaign was just over $5,700.

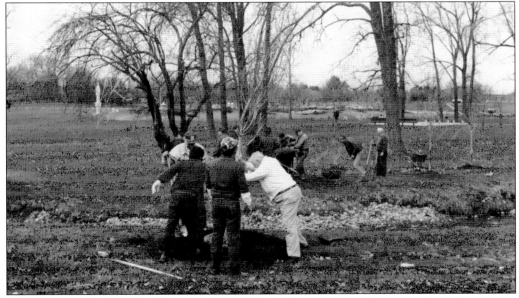

The Plymouth Rotary Club has participated in several "Rotary Cares" projects through the years, helping the community and individuals with labor and money. In April 1988, Plymouth Township Park needed greenery. Club members provided many hours of labor, planting 60 locust and maple trees. The trees were funded by the Plymouth Rotary Foundation to the tune of $4,800.

The Salvation Army was established in Plymouth in 1929. Through the years, the Plymouth Rotary Club has regularly supported the Salvation Army, including providing bell ringers during the holidays. In 1990, the club joined Omnicom Cable TV to sponsor the Salvation Army's food drive "Baskets Filled with Love," which provided 250 needy families with a holiday dinner and toys for kids. Salvation Army lieutenant Jeffrey Beachum displays the campaign's poster.

Rotarian Charles Bennett and wife Carrie visited the china factory in Karlsbad, Czechoslovakia, in 1936, accompanied by the Rotarian factory owner. Bennett was gifted the porcelain Rotary wheel pictured here, which he presented to the club. Years later, the Rotary wheel was rediscovered and refurbished. In 1992, the club brought Petr Jandos (left) from Czechoslovakia to Plymouth as part of the youth exchange program. He is pictured with Rotarian E.J. McClendon.

A YMCA program was first formed in Plymouth in 1962. The Rotary Club stepped up to support it with a donation in 1964 and regularly in subsequent years. The Plymouth Fife and Drum Corps was formed in 1971 from the Plymouth High School band. The Rotary Club has occasionally been a corps supporter. Here, the YMCA's banner precedes the Fife and Drum Corps in the 2011 Fourth of July Parade.

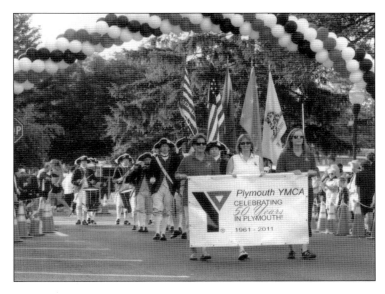

In November 1980, the Plymouth Rotary Foundation committed $5,000 to Plymouth's "Adopt-a-Park" program. The city park at Herald and Wing Streets became the Plymouth Rotary Park with playground upgrades. In June 2013, the park received additional improvements to the play structure, brickwork, trees, and a pet drinking fountain. The ribbon cutting featured, from left to right, Mayor Dan Dwyer of Plymouth, Rotary president-elect Tom Adams, and Rotary president Art Butler.

After the barbeque in 2016, from left to right, Mike Muma, Tony Bruscato, Gary Stolz, Jeff Stella, James Van Horn, Kent Early, Eric Joy, and Rich Eisiminger were present when a check in the amount of $48,000 was given to the Plymouth Rotary Foundation. This contribution had far-reaching effects. In October 2016, the Plymouth Rotary Foundation approved a $10,000 grant to fund the construction of water wells in Malawi.

On Friday, September 8, 2017, President Christina Vega rededicated the newly restored monument that is housed between the Plymouth District Library and Plymouth City Hall. The 50-year-old monument commemorated the 100th anniversary of the incorporation of the village of Plymouth. The lord mayor of Plymouth, England, visited here in 1967 and brought with him a portion of rock from the pier from which the pilgrims on the *Mayflower* set sail.

In 2018, a Little Free Library was installed in Rotary Club Park, located at the corner of Wing and Herald Streets. Members of the club present for the dedication included, from left to right, Tony Bruscato, Penny Joy, John Buzuvis, Paul Sincock, and Chris Porman. With the addition of this feature to the park, the club was providing a fun and quick resource for reading material for the neighborhood.

Rotarian Denise King (right) worked on the team that assembled the boxes at the 2023 barbeque. This was a unique year, as the exchange students from Rotary District 6400 were in attendance and assisted with this process. These students were able to see firsthand what it takes for the club to raise funds for their program. (Photograph by Pete Mundt.)

Early in the 2020 COVID-19 pandemic, the Rotary Club of Plymouth requested these signs to be printed in support of the club's relief efforts. The printer, International Minute Press, sold the signs with a percentage of the sale going to the club. A check for $287 was presented to the Plymouth Rotary Foundation in October 2020 to purchase personal protective equipment. (Photograph by Paul Sincock.)

Rotary International adopted "the Four-Way Test" in 1943. Rotarian Herbert J. Taylor of the Rotary Club of Chicago wrote the test in 1932 to help his aluminum company thwart bankruptcy during the Great Depression. The test has been adopted by Rotary clubs around the world as an ethical guide for use in personal and professional relationships. Members of the Rotary Club of Plymouth try to live by these 24 words.

About the Friends of the Plymouth Historical Museum

The Friends of the Plymouth Historical Museum is a privately funded membership organization dedicated to preserving, teaching, and presenting history through the operation and support of the Plymouth Historical Museum. The Friends (also known as the Plymouth Historical Society) was organized in 1948 with 52 original members. It owns and operates the Plymouth Historical Museum. The museum originally opened in 1962 in a historic home. By 1971, the museum had outgrown its space. A new, purpose-built museum building opened its doors to the public in 1976; an addition was completed in 2001. The museum is housed in a 26,000-square-foot building donated by philanthropist Margaret Dunning. The Plymouth Historical Museum is located at 155 South Main Street in Plymouth. It features a late 19th-century Victorian re-creation of Main Street, tracing the growth of the small town from the railroad depot to the general store. The largest Lincoln collection exhibited in the state of Michigan is housed in a separate room off Main Street. A timeline of Plymouth is in the lower level, featuring displays of Ford Village Industries, the Alter Motor Car, World War II, communication history, and Plymouth's air rifle industry. The museum has three special exhibits each year to highlight the depth of the collections and to spotlight Plymouth as a microcosm of small-town America. In 2019, the Plymouth Historical Museum received a caboose donated by CSX Corporation, which allows further interpretation of Plymouth's rich railroad history.

For more information on the Plymouth Historical Museum, visit www.plymouthhistory.org or call 734-455-8940 x0.

Discover Thousands of Local History Books
Featuring Millions of Vintage Images

Arcadia Publishing, the leading local history publisher in the United States, is committed to making history accessible and meaningful through publishing books that celebrate and preserve the heritage of America's people and places.

Find more books like this at
www.arcadiapublishing.com

Search for your hometown history, your old stomping grounds, and even your favorite sports team.

Consistent with our mission to preserve history on a local level, this book was printed in South Carolina on American-made paper and manufactured entirely in the United States. Products carrying the accredited Forest Stewardship Council (FSC) label are printed on 100 percent FSC-certified paper.